F.C.B. CADELL

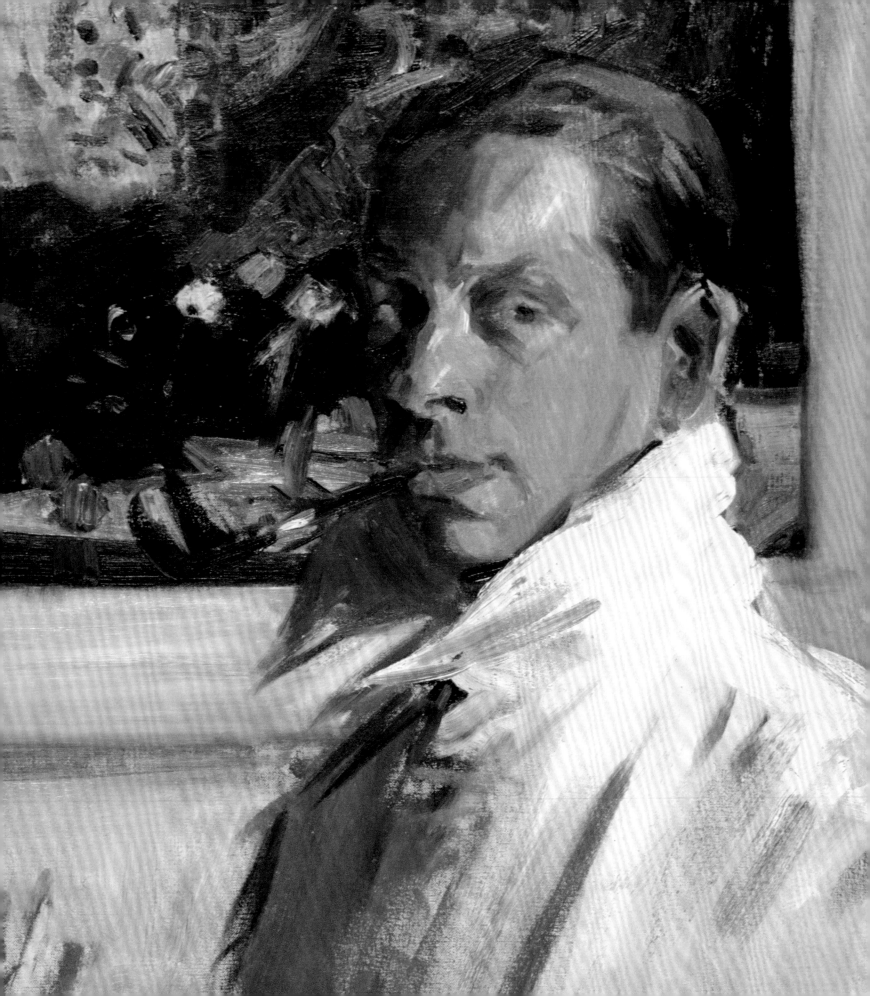

F.C.B. CADELL

Alice Strang

National Galleries of Scotland
Edinburgh 2011

First published by the Trustees of the National Galleries
of Scotland to accompany the exhibition, *F.C.B. Cadell*,
held at the Scottish National Gallery of Modern Art,
Edinburgh, from 22 October 2011 to 18 March 2012,
with a tour of selected works to The McManus:
Dundee's Art Gallery and Museum, 6 April – 17 June 2012.

Reprinted 2017

ISBN 978 1 906270 40 7

Designed and typeset in Arnhem by Dalrymple
Printed on Perigord 150gsm by Conti Tipocolour, Italy

Front cover: detail from *Portrait of a Lady in Black* [49]
Back cover: detail from *The Village, Iona* [87]
Frontispiece: detail from *Self-portrait* [22]

The proceeds from the sale of this book go towards
supporting the National Galleries of Scotland. For a complete
list of current publications, please write to National Galleries
of Scotland Publishing, Scottish National Gallery of Modern
Art, 75 Belford Road, Edinburgh EH4 3DR, or visit our website:
www.nationalgalleries.org

National Galleries of Scotland is a charity registered in
Scotland (no.SC003728)

NATIONAL
GALLERIES
SCOTLAND

CONTENTS

SPONSOR'S FOREWORD

Dickson Minto ws, established in 1985, is a leading multinational practice law firm providing corporate and commercial legal services to national and international clients. With offices in London and Edinburgh, the firm is committed to delivering the highest standard of service to all clients whether small, medium or large, private or public. We also have a high regard for the visual arts and are delighted to be sponsoring the exhibition *F.C.B. Cadell*, our first sponsorship with the National Galleries of Scotland. Cadell is known as one of the group of artists called the Scottish Colourists but this exhibition, the first at a public gallery since the memorial exhibition in 1942, provides a unique opportunity to re-assess the artist on his own merit. The youngest of the Colourists, Cadell's works have a vibrancy and charm and are as popular today as they were when they were painted. The works included in the show range from his beautiful, idyllic paintings of Iona, the island he loved so dearly, to his strikingly original interiors in Edinburgh's New Town. We are especially pleased to be associated with this very important initiative by the National Galleries of Scotland as the firm's first Edinburgh offices were located in Ainslie Place, the home for many years of the artist himself.

We know that this exhibition will give enormous pleasure to every visitor and we are delighted to have had the opportunity to support it. We look forward to extending our relationship with the National Galleries of Scotland for many years to come.

DIRECTORS' FOREWORD

This book accompanies the first solo exhibition of the work of Francis Campbell Boileau Cadell to be held in a public gallery since 1942, when the National Gallery of Scotland mounted a memorial exhibition only five years after the artist's death. Cadell is invariably associated with the Scottish Colourists, namely J.D. Fergusson, G.L. Hunter and S.J. Peploe. There certainly were affinities between the four artists as they all spent time in France, particularly in Paris, and shared a love of brilliant colour, taken in part from Fauve artists such as Matisse and Derain. However, the idea of linking their work into a group or movement was really based on commercial interests. The art dealer Alexander Reid and his son A.J. McNeill Reid exhibited the four artists together for the first time in 1924, but even so it was not until 1948 that the term Scottish Colourist was first coined, when three of the four artists were already dead. And, while it is useful to consider them as a group, the fact that they were four independent artists with different aims and ambitions is easily lost. The purpose of this exhibition and publication is to assess Cadell on his own terms. In 2012 we shall do likewise with Peploe and in 2013 we shall turn our attention to Fergusson. (Hunter will be the subject of a major exhibition at the City Art Centre in Edinburgh in 2012.)

Our thanks are due to the lenders to the exhibition without whose generosity this project would have been impossible. We are indebted to the many others who have facilitated loans and helped with research, in particular the descendants of various branches of Cadell's family and those of his patrons, as well as Tim Cornwell and Dr Lorn Macintyre. We are also grateful to Tom Hewlett of the Portland Gallery who has represented the Cadell Estate since 1988 and who published the standard monograph on the artist. Particular thanks are also due to: Roger Billcliffe, The Billcliffe Gallery; Patrick Bourne, The Fine Art Society; Alexander Meddowes; Duncan Miller of Duncan R. Miller Fine Arts; Ewan Mundy of Ewan Mundy Fine Art; Guy Peploe, grandson of S.J. Peploe and Managing Director of The Scottish Gallery; and Selina Skipwith of The Fleming Collection.

At the auction houses we are grateful to Chris Brickley and Jonathan Horwich of Bonhams; Philip Harley, André Zlattinger and Bernard Williams, Christie's; Campbell Armour and Nick Curnow, Lyon & Turnbull; and Michael Grist, Sotheby's. For their research into Cadell and Iona we acknowledge the assistance given by Jessica Christian, Philip MacLeod Coupe and Charles Stiller. Within the National Galleries of Scotland, the exhibition has been curated by Alice Strang, who has written this book. We would also like to thank all those at the National Galleries of Scotland who have been involved with the realisation of this project.

Finally, we are indebted to our sponsor, Dickson Minto ws, for their generous support.

SIR JOHN LEIGHTON
Director-General, National Galleries of Scotland

DR SIMON GROOM
Director, Scottish National Gallery of Modern Art

INTRODUCTION

ALTHOUGH grouping the four Scottish Colourists, namely F.C.B. Cadell, S.J. Peploe, J.D. Fergusson and G.L. Hunter, together has its benefits, it also has the effect of smoothing over their differences and making them seem like a coherent group, with shared ideas and ideals, which is not really the case. The various stages of their careers, including their education and their formative years as artists, occurred at different times, rather than in parallel.

Cadell [22] can perhaps be considered the most Scottish of the group. He was born in Edinburgh and lived there for most of his life. From 1912 until his death he spent almost every summer on the Hebridean island of Iona, as is examined in a separate chapter, and rarely travelled to London. He was proud to be a Scot and often wore a kilt. During the immediate pre-war period, Fergusson, Peploe and Hunter experienced the birth of modern French painting in Paris at first hand. In contrast, Cadell found inspiration in the light, architecture and society of the Scottish capital, and on his beloved island of Iona. And if Fergusson, Peploe and Hunter sought inspiration in the work of Matisse and the Fauves, Cadell's points of reference were James McNeill Whistler, John Singer Sargent and John Lavery. He had the closest professional ties with the Glasgow Boys, not least through Arthur Melville, who was his younger brother's godfather, and at whose suggestion Cadell studied in Paris.[1] He was colleagues with Lavery and James Paterson, with whom he co-founded the Society of Eight exhibiting society in 1912. Cadell was also friends with the sculptor James Pittendrigh Macgillivray and he knew W.Y. MacGregor well, describing him as 'the greatest of Scottish landscape painters'.[2]

It is difficult to separate Cadell himself from his work: he was charismatic, sociable and dressed with élan [2]. He has suffered from the reputation of being a 'gentleman painter' and was not as intellectual or political as Fergusson. Cadell took great pains over the fashionable decoration and furnishing of his studios, where he played host to elegant members of Edinburgh's upper class. Cadell worked confidently in a wider range of genres than his colleagues, painting interiors, still lifes, figure studies and landscapes. His unpeopled interiors and disciplined still lifes of the 1920s are unique amongst the Colourists and indeed in twentieth-century British art.

Cadell was the youngest of the Colourists and the only one to be elected to the Royal Scottish Academy and the Royal Scottish Society of Painters in Watercolour. Despite appearances and in part because of the lavish lifestyle he led, Cadell was beset with financial problems throughout his life. Although a regular exhibitor at the annual exhibitions of the Royal Scottish Academy and the Royal Glasgow Institute, and one of the stable of artists shown at The Scottish Gallery in Edinburgh and Alexander Reid's gallery in Glasgow, Cadell was unusual for the amount of work he sold directly to patrons. This seems to have caused problems with his dealers, and it meant that he found himself with little professional support when he encountered serious financial difficulties in the latter part of his life. Pittendrigh Macgillivray summed up Cadell's artistic achievements thus: 'It seems to me ... that your forte lies in a gift of colour and light – these seen in a joyous mood.'[3]

NOTE: *Although Cadell usually signed his works, he rarely dated them. When paintings can be identified in exhibition lists or from other archival sources, dates are given; otherwise approximate dates are suggested. Dimensions are in centimetres, height before width.*

[1] Detail from
The North End, Iona
[78]

1 · THE BIRTH OF AN ARTIST

FRANCIS CAMPBELL BOILEAU CADELL was born on 12 April 1883 at 4 Buckingham Terrace, Edinburgh, and was named after both of his parents. His father, Francis Cadell, was a surgeon who became Surgeon Major to the Queen's Royal Volunteer Battalion (Royal Scots) whilst his mother, Mary Hamilton Boileau, was the daughter of General Alexander Henry Edmonstone Boileau of the British Indian Army, whose family were originally from Nîmes in the south of France.[4] They married in London on 21 June 1882, although it would appear that they had known one another for some time as Mary is listed in both the 1871 and 1881 Edinburgh census at the home of her future husband's mother. However, the family connection was established even earlier as, after the death of her first husband in 1862, Mary's mother, Matilda Grace Tovey, married Francis's elder brother Alexander Cadell (later Major General Alexander Cadell, Bombay) in 1864.

Francis Cadell senior was a figure of some standing in society. Educated at the University of Edinburgh, he became a Fellow of the Royal College of Surgeons of Edinburgh in 1870 and served as Secretary from 1890 until 1905. He was a member of the Royal Company of Archers, the Sovereign's Body Guard for Scotland. His obituary in the Edinburgh Medical Journal stated: 'few men were better known by sight in Edinburgh than he; his striking figure and well-known visage could hardly escape recognition.'[5]

'Bunty', as the younger Francis was known, was the eldest of three children [3]. He was particularly close to his sister Jean Dunlop Cadell, who became a Scottish character actress, best known for her role in the 1948 film *Whisky Galore*. Their younger brother, Arthur Patrick Hamilton Cadell, was a godson of the artist Arthur Melville and became a Colonel in the British Indian Army. It is not known how the family knew Melville, but the connection suggests some family interest in art.

In 1889 the family moved to 22 Ainslie Place, an elegant double crescent in Edinburgh's Georgian New Town. Cadell showed artistic ability from an early age, which was encouraged by his family. His mother compiled scrapbooks of drawings he made from the age of three until twenty. Cadell attended Edinburgh Academy, where his school report at the age of nine noted that: 'A pencil in his hand at any time is dangerous to lessons.'[6] It was at Arthur Melville's suggestion that Cadell continued his artistic education in Paris, as Melville and many of the Glasgow Boys had done themselves. This was an unusually bold move, considering that he had, seemingly, no training beyond art classes at school. Cadell, his sister Jean and their mother left his father and Arthur at home and moved to the French capital in 1898, when Cadell was sixteen, with the family reuniting for summers in Normandy [5].[7] Cadell enrolled at the Académie Julian in 1898. Correspondence between his parents during this period frequently refers to concern over Cadell's behaviour and requests for money. In one letter, his mother laments at having to retrieve his bicycle at great expense after Cadell left it at Montparnasse: 'Genius is an expensive thing – but I shall forgive him if he really has the genius, and not only the expensiveness.'[8]

It is unclear how much, if any, contemporary French art Cadell would have seen, but work by the Impressionists was on display at the Musée du Luxembourg and the landmark Van Gogh exhibition was held at the Galerie Bernheim-Jeune in 1901. Jean recalled continual visits to museums and galleries, which may have included those of Bernheim-Jeune,

Boussod & Valadon, Paul Durand-Ruel, Georges Petit and Ambroise Vollard, who mounted displays of work by leading French artists during this period. However, in a letter to his father, Cadell reserved his highest praise for the Scottish painter Sir Henry Raeburn.[9]

Little work of this period survives, but Cadell considered himself a serious artist from an early age.[10] It appears that Cadell remained in France with his mother and sister until 1902 (only Cadell's father and brother are listed at 22 Ainslie Place in the census of 1901) and records show that he began submitting work to the main annual exhibitions held in Edinburgh, showing with the Royal Scottish Academy and the Society of Scottish Artists for the first time in that year.[11] From 1902 until 1905 Cadell lived between Edinburgh and Paris and tentatively embarked upon a professional career. He showed four works in the Salon de la Société national des beaux-arts of 1903, with his address registered as 8 *bis*, rue Campagne-Première, Paris whilst for the 1904 Society of Scottish Artists' exhibition he is listed as at 22 Ainslie Place; when he showed two works at the 1905 Salon, he is resident at 65 boulevard Arago, Paris.

When in Edinburgh Cadell undertook portrait commissions from friends and relatives, including Mrs William Wood, whose house at 4 Oxford Terrace became something of a second home to him. In return for hospitality provided during extended visits, Cadell would paint portraits of his hosts and even their pets. As a result he established the basis of long-standing private patronage which was to sustain him throughout his life. His most significant patrons at this date were George Lyall Chiene, for whom Cadell acted as best man in 1902 and who became Surgeon to Edinburgh's Royal Infirmary; and Charles Edward Stewart, known as 'Ted'. Ted was the fourth son of William Stewart of Shambellie in New Abbey, Dumfries (which was Ted's childhood home and is now the National Museum of Costume) and so, like others in Cadell's orbit, was a figure of some standing in Edinburgh society [4]. He became Cadell's solicitor, de facto manager and executor. Cadell frequently visited Ted at Shambellie, painting Mr Price the spaniel and Puggy the pug dog in 1908.[12]

In 1905 Cadell's father retired from medicine in Edinburgh. In 1906 the family moved to Germany, without Arthur who joined the Royal Military College at Sandhurst that year. It has been thought that this was due to reasons of declining health and finances.

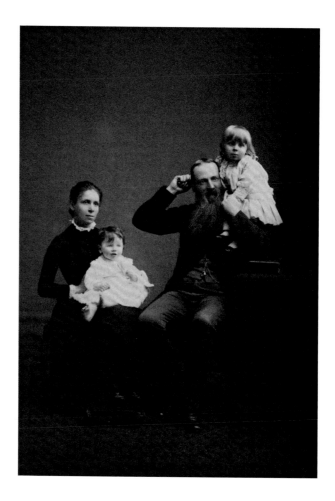

[3] Francis and Mary Cadell with Bunty and Jean, c.1886
Private Collection

[4] Andrew Jameson McCulloch (left), Cadell (centre) and Charles Edward Stewart (right) at Shambellie, c.1902
Private Collection

However, after spending some months in Gotha, the family settled in Munich in late 1906, where Cadell's father is registered as a practising physician. On 4 May 1907 Cadell, aged twenty-four, enrolled at the renowned Akademie der Bildenden Künste, joining the drawing class of Angelo Jank. Munich was the artistic capital of Germany and its academy was a popular choice for young foreign artists wishing to continue their studies. The family lived on the second floor of Karlstraße 10 but Cadell took his own apartment at Nordendstraße 14 in November 1907, where he registered himself as an 'Artist'.[13] Little is known of the family's time in Germany, but they presumably intended to remain there as by the end of 1907, they had sold their house in Ainslie Place.[14]

The Symbolist artist Franz von Stuck was the leader of the Munich Secession, established in 1892, and Professor at the Munich Academy. His home, Villa Stuck, built in 1897, adhered to the contemporary idea of the architectural Gesamtkunstwerk or 'total work of art'. Stuck designed the entire house and decorative scheme, creating a living space which encompassed his artistic aesthetic – a philosophy which Cadell was to emulate in his own studios. Cadell may have been influenced by seeing the work of German

Impressionists including Max Liebermann and Lovis Corinth, but shows no sign of an awareness of avant-garde artists based in Munich then, including Wassily Kandinsky and Alexej von Jawlensky. The death of Cadell's mother on 16 December 1907 led to the family's return to Edinburgh early the following year.[15] Cadell sought refuge at Shambellie and completed a series of watercolours for his father's third cousin, Henry Moubray Cadell, for the drawing room at his new home Grange, outside Linlithgow. He also lived with Mrs Wood at 4 Oxford Terrace, at whose address he is registered for the 1908 and 1909 exhibitions of the Society of Scottish Artists.

Cadell's first solo exhibition was held at Doig, Wilson & Wheatley, Edinburgh in 1908. It included works which showed an impressionist technique and a confident handling of oil paint. The exhibition resulted in an impressive twenty-five sales. These are recorded in Cadell's Register of Pictures, which he compiled from 1907 until 1930. Entries in black indicated sales, whilst those in red were given as presents; at the end of each year he calculated his annual total income.[16] Patrick Ford, who had been in Cadell's year at the Edinburgh Academy and who later became a Scottish Unionist Party politician, was amongst those who purchased from the exhibition and became a major and enduring patron.

Cadell's father died in Newton Stewart, Wigtownshire on 12 February 1909. The cause of death was given as a thrombosis. He left an estate worth £2,751.[17] Shortly afterwards, Cadell secured his first professional studio in Scotland at 130 George Street, Edinburgh. Meanwhile, Jean departed for London to embark upon a career on the stage and married the actor Perceval Perceval-Clarke in 1910. Cadell's association with The Scottish Gallery, founded in 1897 as part of Aitken Dott & Son, the gilders, framers and artists' materials supplier, began with a solo exhibition in 1909. That year he also sent work to the annual exhibitions of the Royal Glasgow Institute and the Royal Scottish Society of Painters in Watercolour, for the first time.[18] By 1909 Cadell had met Peploe (who also had a solo exhibition at The Scottish Gallery that year), thus beginning a lifelong friendship, which was to have significant impact on the work of both artists.[19]

[5] F.C.B. Cadell in Normandy, c.1900
Private Collection

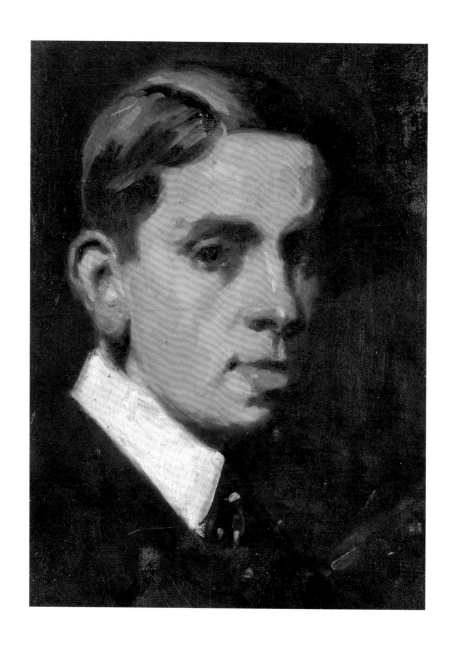

[6]

Self-portrait, early 1900s

Oil on canvas, 38.1 × 27.9
Collection of Nigel E. Doughty

[7]

The Dining-Room, Inveraray, c. 1910

Oil on board, 45 × 35.6
Private Collection

2 · A Colourist Emerges

THE FIRST ENTRY FOR 1910 in Cadell's Register of Pictures is 'Cheque from P.J. Ford Esq to go to Venice and paint. He to choose equivalent in pictures on return £150.' This advance enabled Cadell to travel to northern Italy, a journey he undertook in the company of the poet Ivar Campbell [10].[20] It is uncertain how the two met but a record of their trip can be found in a book of poems by Campbell which was published posthumously in 1917, including one dedicated to Cadell.[21] Campbell was the only son of Lord and Lady George Campbell and a grandson of the 8th Duke of Argyll.

Venice's beauty and grandeur, seen in mirror image in her watery surroundings, prompted an interest in reflections that became a defining characteristic of Cadell's work. His technique became much freer and he adopted a brighter palette. Initial, conservative paintings of church interiors gave way to vigorous, rich images of Venice, such as the patrons of Florian's Café in St Mark's Square, the façade of St Mark's Cathedral and views across the lagoon [12–14]. Some of these works were painted outdoors on modestly-sized boards which were easy to transport. Cadell painted quickly and fluently, with dabs of bright colour applied with defined brushstrokes. The early promise of some of his bolder landscapes, painted as far back as the family's summers in Normandy, finally emerged with conviction. Cadell exhibited the results of his Venetian trip at The Scottish Gallery in November 1910, and Patrick Ford received six paintings in return for his patronage.

Cadell's studio at 130 George Street was extremely stylish [9, 21, 25]. He painted the walls of the finely proportioned Georgian rooms in pale shades of white, grey and lilac and the floorboards black, which were then polished to a glimmering shine. The studio was furnished sparsely, with a grand piano, a Louis XV-style armchair upholstered in black-and-white striped material, an impressive chandelier and a sofa covered in white as focal points. There was also an imposing white marble fireplace, topped by a series of overmantels. This light, airy and minimal interior became the subject matter for some of Cadell's most celebrated pre-war paintings.

Cadell developed a palette based on a range of whites, creams and beiges, a prominent use of black – influenced by the French artist Edouard Manet – with highlights of bright colour, and a technique of feathery, loaded brushstrokes. His *Crème de Menthe* of around 1915 [27] is somewhat reminiscent of Manet's *Un bar aux Folies-Bergère*, in its depiction of a woman positioned in front of a mirror and behind a counter or table, on which stands a complex still-life composition.[22]

Cadell explored the genre of the still life in the pre-war period, as can be seen in works such as *Still Life with Silhouette* of around 1912 [17]. The green of the holly and the bowl and the yellow of the lemon sing out within their essentially black and white environment. This painting is a fine early example of Cadell's orchestration of still-life objects, such as vases, fans and jugs, items to which he was to return for inspiration time after time. By contrast, in *Still Life with White Teapot* painted in 1913 [15], Cadell used white as the base colour for his objects, again arranged on a black table top for contrast, but this time placed within a vividly coloured and broadly painted setting which is implied through rudimentary, even crude, brushstrokes of colour. This technique can also be seen in Cadell's *Self-portrait* of about 1914 [frontispiece and 22] in which the lower half is summarily sketched. He presents himself full of confidence, with a large

[8] Detail from *Florian's Café, Venice* [13]

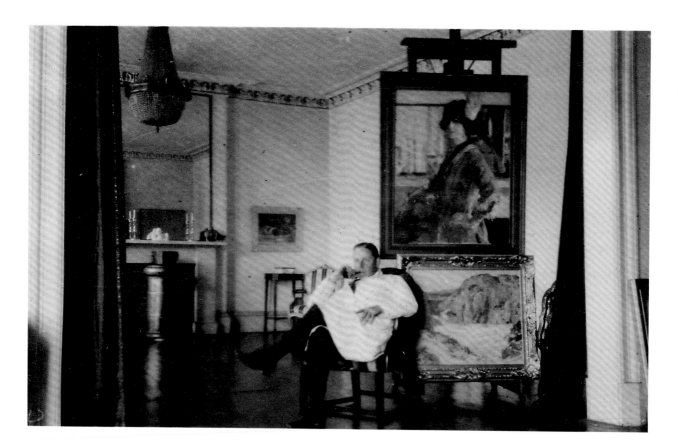

palette and a container of paintbrushes. Behind him hangs a colourful painting, most likely one of his own, a conceit that Cadell was to employ for the rest of his career.

Unlike Fergusson, Cadell painted few female nudes and these only before the war. The large painting *The Model* [16] is an early example of Cadell's theme of a woman within a beautiful interior, standing and reflected in a mirror, or seated on a sofa. However, her face is largely unmodelled, rendering her impersonal and presenting her like a prop rather than an individual. Cadell and Peploe both used the professional model Peggy McCrae but Cadell's most celebrated model was Miss Bethia Hamilton Don Wauchope, the daughter of Sir John Don Wauchope and Bethia Hamilton. She was a wealthy society figure, whose family home was 12 Ainslie Place and who sat for Cadell for some fifteen years.[23] She is believed to be one of the models depicted in *Afternoon* of 1913 [21], which depicts three women in the George Street studio and which was sold at the Royal Scottish Academy in 1915 for £80. *Afternoon* can be read as three paintings in one: the contemplative woman seated in front of the mantelpiece, the delicate still life in the foreground

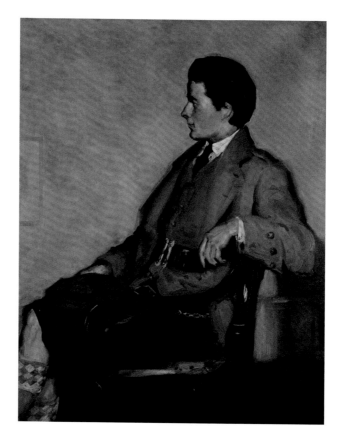

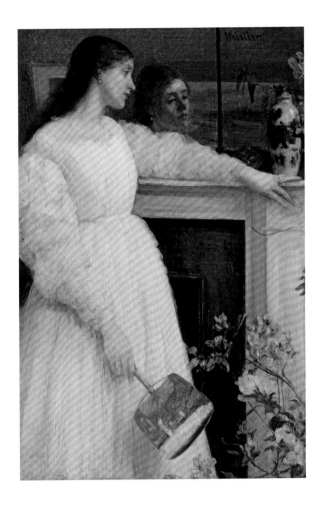

[11] James McNeill
Whistler, *Symphony in
White No.2: The Little White
Girl*, 1864
Tate

and Sargent. His colours of this period have been likened to those of the Scottish Impressionist William McTaggart, considered the grandfather of the Scottish Colourists.[25] However, he most openly declared his admiration for Whistler, who had a considerable following in Scotland, remarking:

He was a marvellous painter, the most exquisite of the 'moderns' and he had what some great painters have, a certain 'amateurishness' ... I can best describe what I mean in these words, 'A gentleman painting for his amusement' ... Raeburn on the other hand was a 'professional' if ever there was one.[26]

In about 1913 Cadell embarked on a series of images of women standing at his studio mantelpiece, reflected in its overmantel [19, 20], which appear to pay homage to Whistler's *Symphony in White No.2: The Little White Girl* of 1864 [11]. This painting was exhibited at the Royal Scottish Academy in 1902, and two years later the Academy mounted a memorial exhibition of Whistler's work. Peploe was another great admirer of Whistler, and this interest must have provided a point of contact during the early years of his friendship with Cadell. Peploe spent 1910 to 1912 in Paris, but on his return the older artist became something of a mentor to Cadell. T.J. Honeyman, the art dealer and eventual Director of Glasgow Art Gallery, remarked:

The Peploe and Cadell friendship was a rare thing. In appearance, manner and talk they were poles apart, but in their love of colour, sunshine and freedom of action they were on common ground ... Cadell's studio was about the only one S.J. ever visited. They often criticised each other's work, suggesting an improvement here and there, counselling elimination of some passage or advising a fresh attempt.[27]

In 1912, Cadell visited the Hebridean island of Iona for the first time and he returned regularly thereafter. The early Iona works are executed with glossy, creamy oil paints and they are more summary than the precise images of the post-war years [78–80]. The ever-changing light conditions on Iona, the effect of sunshine on the shallow water along the beaches of dazzling white sand, the intensity and range of colour of the surrounding sea, sky and land, the complexity of its rock formations and wide range of views within and beyond the island, inspired Cadell time after time and he returned to Iona most summers until about 1933. It was whilst on Iona in 1912 that Cadell met the

and the conversation piece between the two women on the right. Accents of colour, like the green and red cushions on which the women sit, the pink of the flower arrangement and the orange of the painting on the wall, enliven the otherwise black, white and grey palette.

Cadell developed the genre of the interior to great effect during this period, following in the footsteps of Scottish painters such as Sir David Wilkie and Sir William Quiller Orchardson. He began painting the interiors of the homes of his friends, relations and patrons before 1910 in return for their hospitality when he was without a fixed abode. Thus he painted the Saloon of Inveraray Castle, Argyll [7]. This was the seat of the Duke of Argyll, the chief of the Campbell clan. Cadell stayed there on several occasions through his connection with Ivar Campbell. It was during one such visit that the duke presented Cadell with a kilt of Campbell tartan.[24]

Cadell's work of this time shows an interest not only in the work of Manet, but also in that of Lavery

Glasgow shipowner George W. Service who became one of his most significant patrons and bought the first of many paintings when they returned to the island the following summer.

Back in Edinburgh, Cadell was a co-founder of the artists' collective the Society of Eight in 1912; its other members were Patrick W. Adam, David Alison, James Cadenhead, James Paterson, Harrington Mann, Sir John Lavery and A.G. Sinclair, with Ted Stewart acting as secretary. It was one of several exhibiting societies set up during this period as an alternative to the vast annual exhibitions of uneven and often conservative content staged by the Royal Scottish Academy, the Royal Glasgow Institute, the Royal Society of Water-colour Painters in Scotland and the Society of Scottish Artists. With fewer artists involved, each could show more works than was permitted in the other exhibitions. They found premises at 12 Shandwick Place, in the west end of Edinburgh, and held their first exhibition there in November 1912. The Society of Eight played a fundamental role in Cadell's career, and he was represented in all their exhibitions until his death in 1937, often borrowing paintings which he had already sold in order to showcase his best work.[28] His Society of Eight sales, along with the sale of Iona paintings, formed the backbone of Cadell's income. In this first year he sold five works from the exhibition, contributing significantly to his total recorded annual income of £187 1s 1d.

Although Cadell would have been able to see examples of French Post-Impressionist works by Cézanne, Gauguin, and Van Gogh at the Society of Scottish Artists' exhibition in 1913, they appear to have had little immediate effect on his work. In contrast, during the period from 1910 until 1914, Fergusson was living in Paris, Peploe lived between Edinburgh and the French capital and Hunter worked in France, digesting cutting-edge developments in modern painting, such as Cubism and Fauvism. Nor did Cadell show any interest in developments in London, such as Wyndham Lewis's Vorticist movement. Instead, he found inspiration in the city of his birth. He revelled in the northern light of the Scottish capital, the elegance of its architecture and the sophistication of its inhabitants, making them the subject matter of his art.

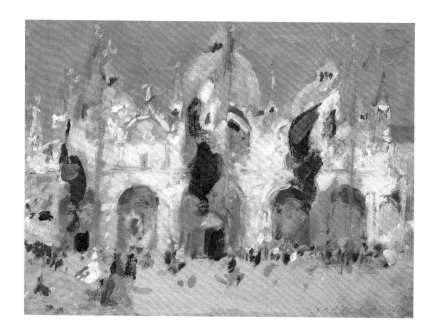

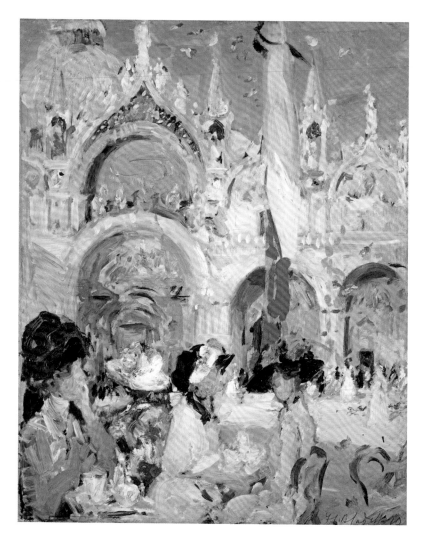

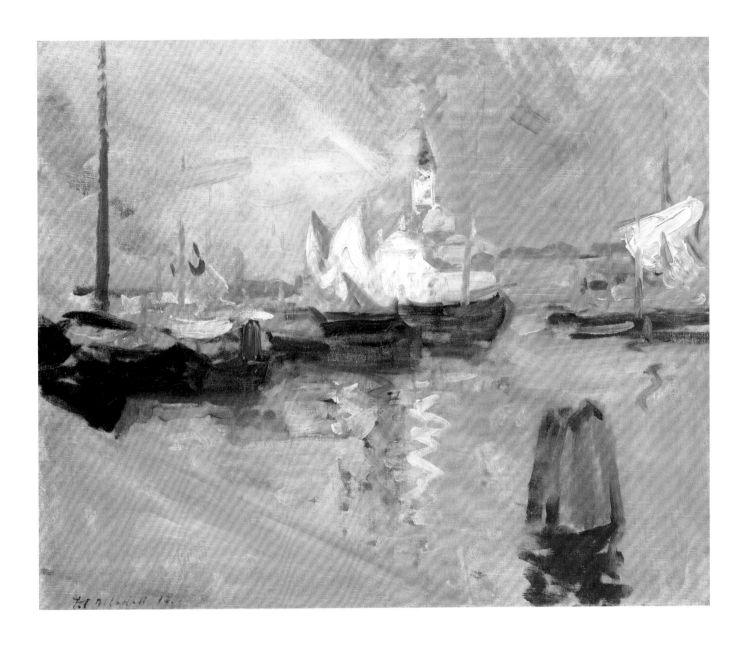

[12]

St Mark's Square, Venice, 1910

Oil on panel, 22.5 × 30.5
Private Collection

[13]

Florian's Café, Venice, 1910

Oil on panel, 45 × 38.1
Private Collection

[14]

San Giorgio Maggiore, Venice, 1910

Oil on canvas, 48.8 × 59.3
Private Collection

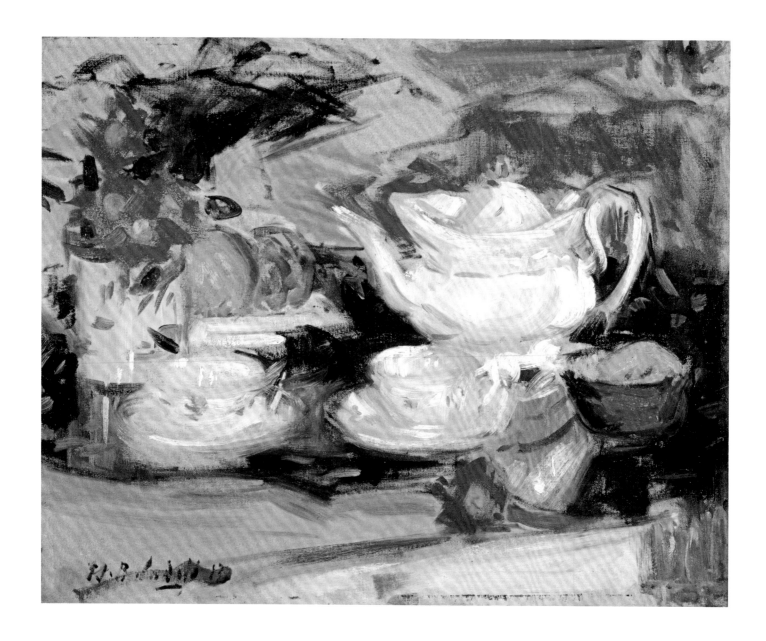

[15]
Still Life with White Teapot, 1913
Oil on canvas, 48 × 61
Private Collection

[16]
The Model, *c*.1912
Oil on canvas, 127.2 × 101.6
Scottish National Gallery of Modern Art,
Edinburgh

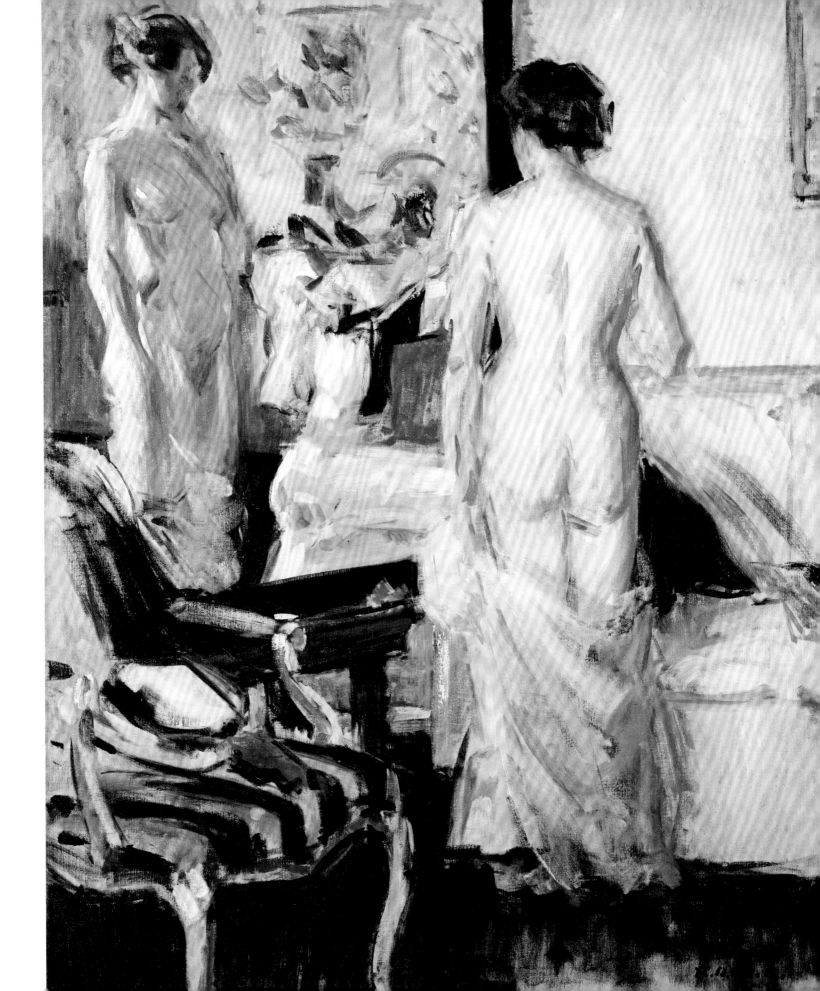

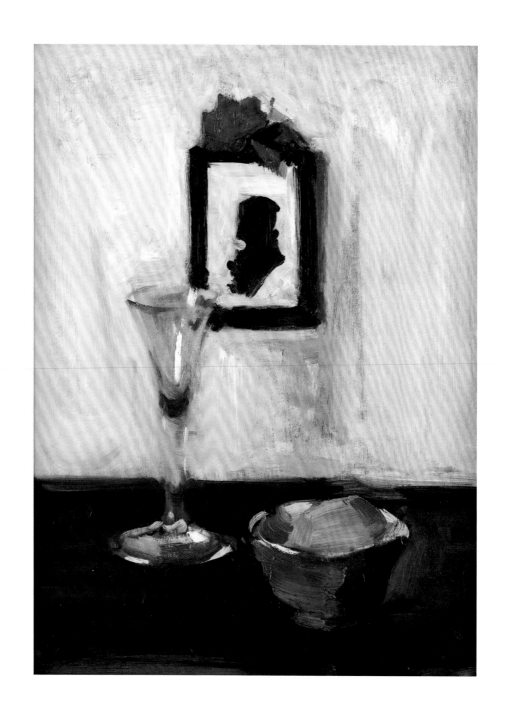

[17]

*Still Life with Silhouette, c.*1912

Oil on panel, 44.4 × 37.6
The Ellis Campbell Collection

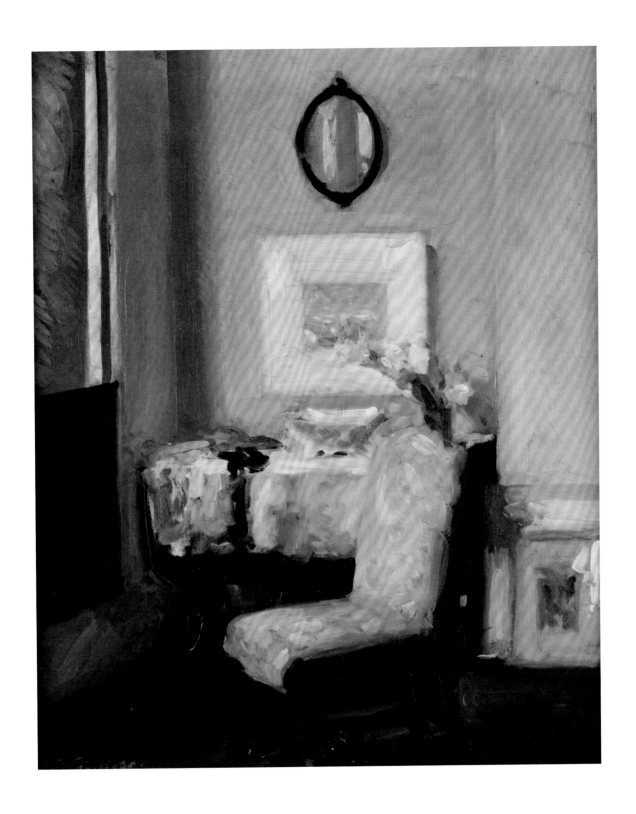

[18]
Interior with Pink Chair, c.1913
Oil on board, 61 × 51
Private Collection

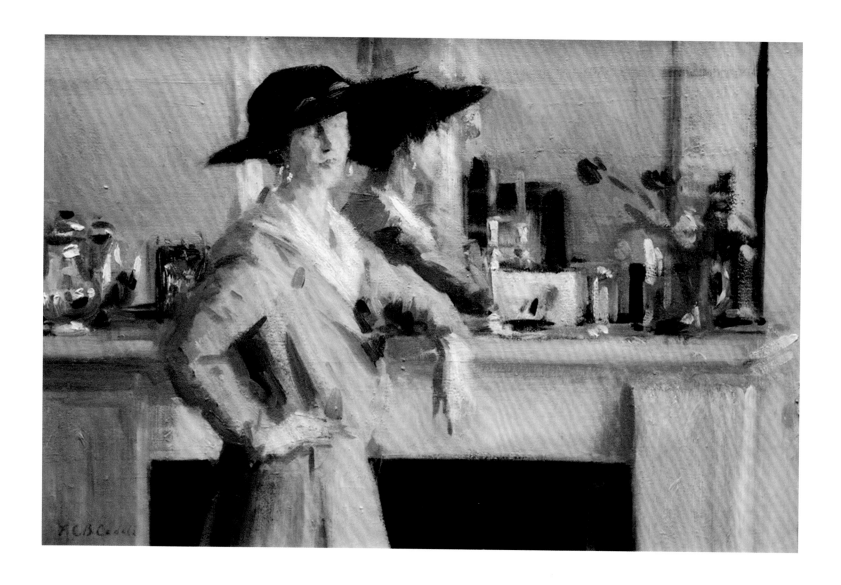

[19]
*The Mantelpiece in Summer, c.*1914
Oil on canvas, 50.8 × 76.3
Private Collection

[20]
The Black Hat, 1914
Oil on canvas, 107 × 84.5 · City Art Centre, City of Edinburgh
Museums and Galleries

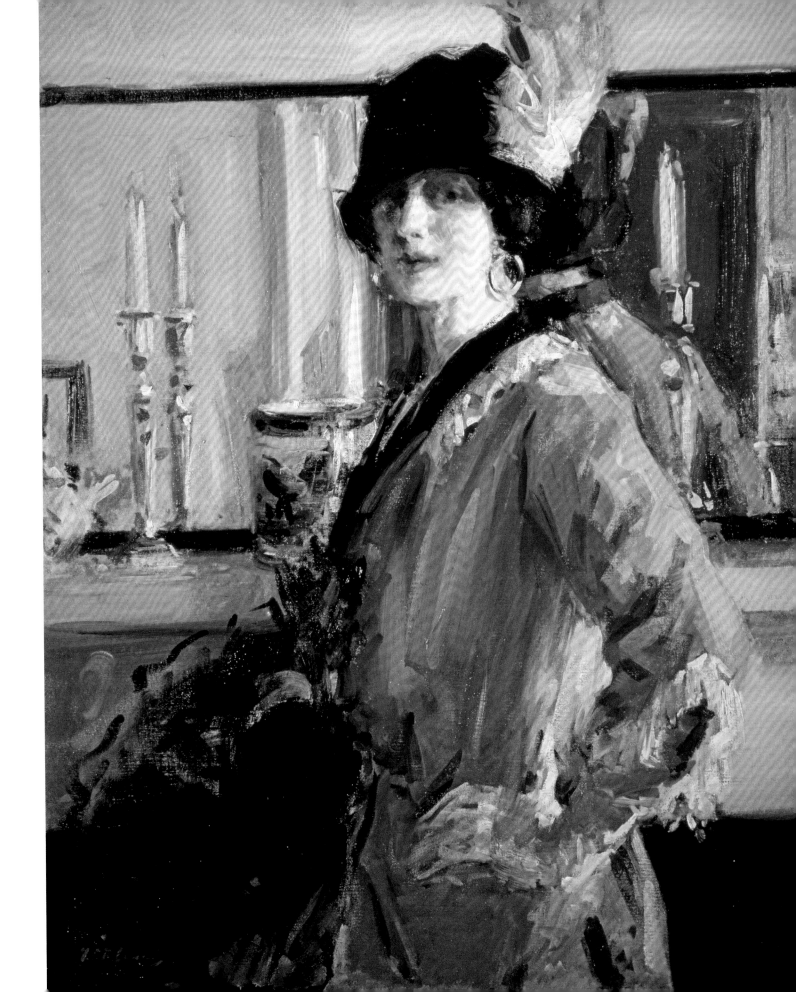

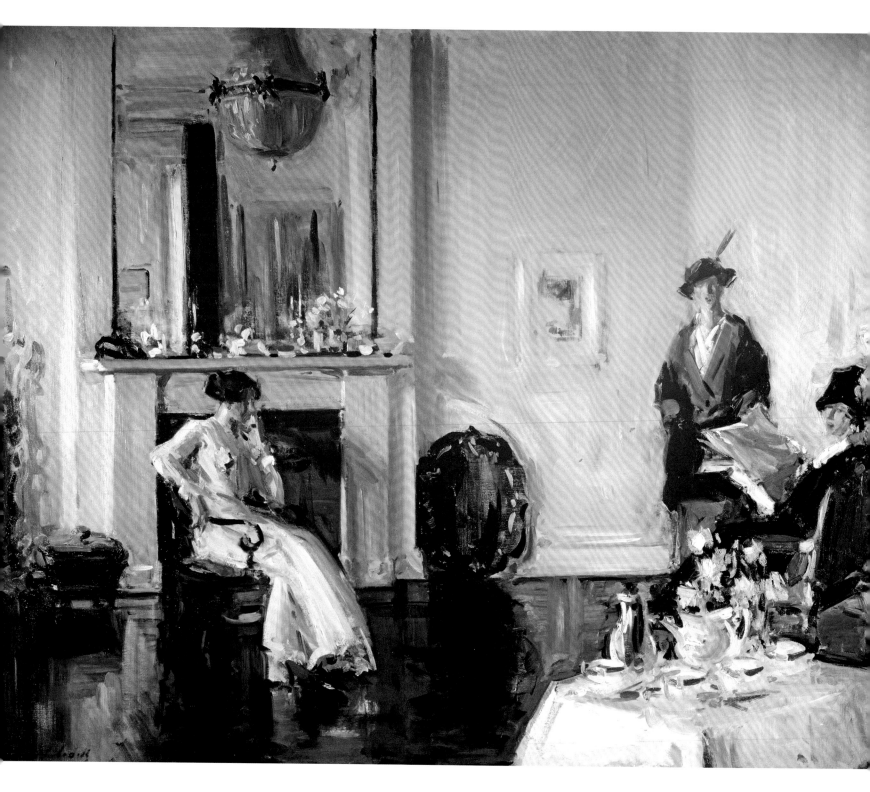

[21]

Afternoon, 1913

Oil on canvas, 101.5 × 127 · Private Collection

[22]

*Self-portrait, c.*1914

Oil on canvas, 113.1 × 86.8 · Scottish National Portrait Gallery, Edinburgh

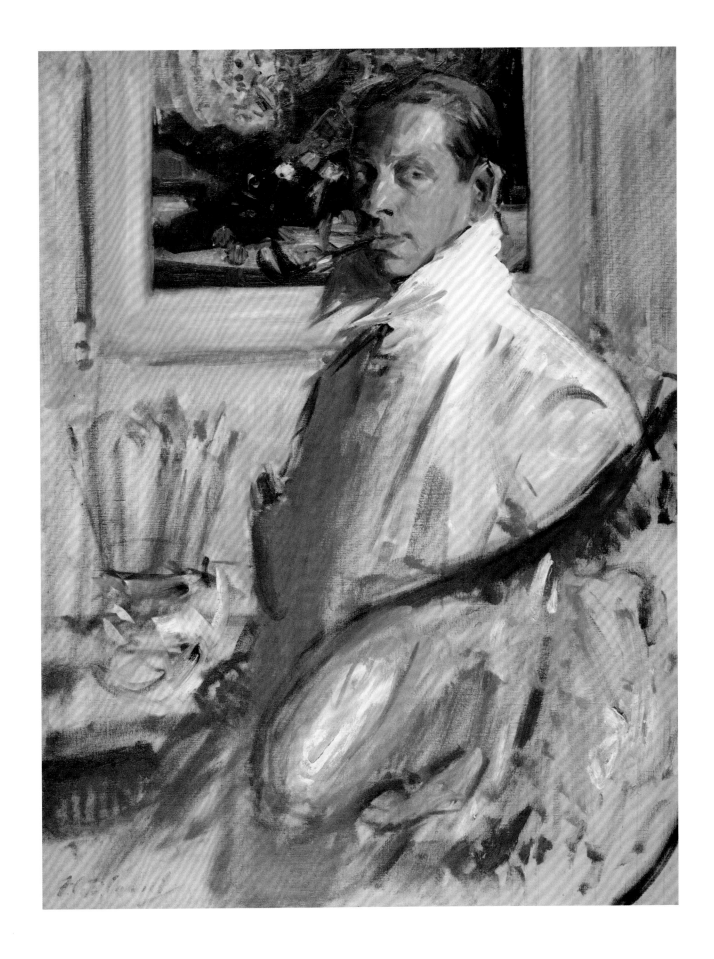

[23]
The White Room, 1915
Oil on canvas, 61.5 × 74
Private Collection

[24]
*The White Sofa, c.*1914
Oil on canvas, 63.5 × 76.5
The Ellis Campbell Collection

[25]
*Interior: 130 George Street, c.*1915
Oil on canvas, 127.5 × 102
Private Collection

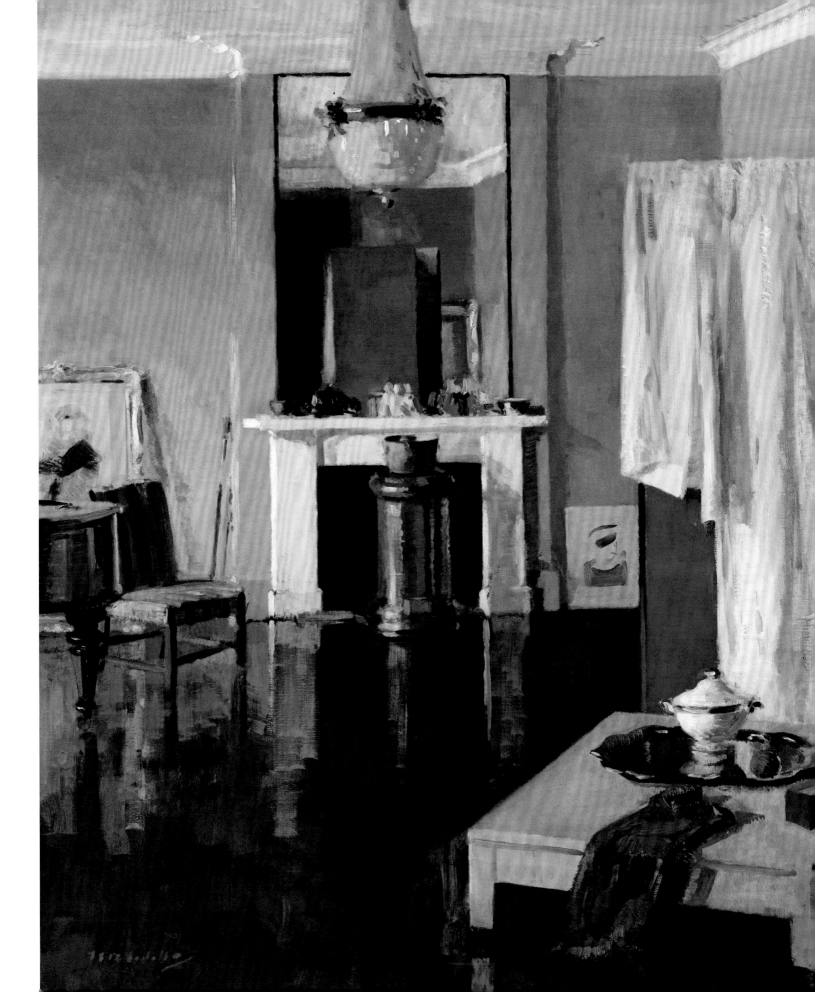

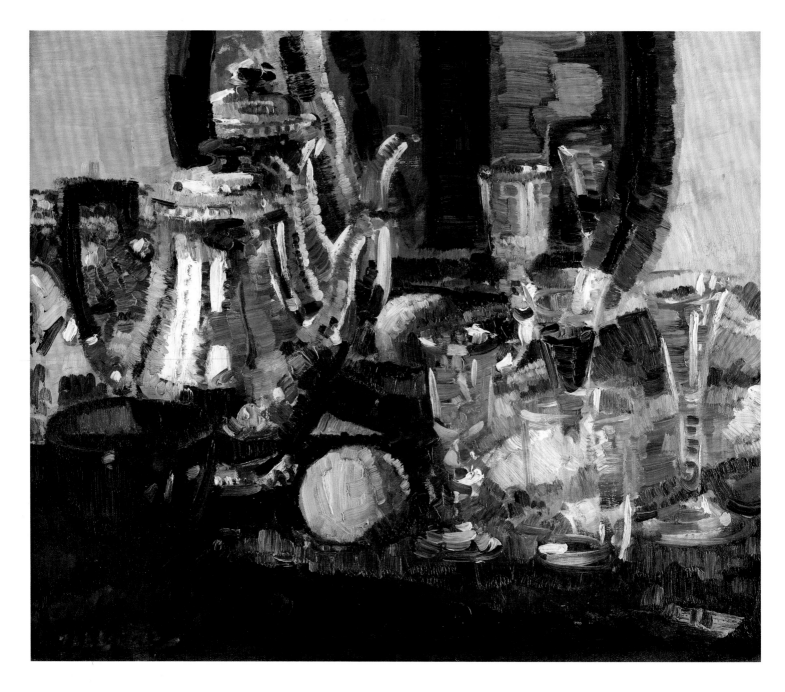

[26]

Reflection: The Silver Coffee Pot, 1913

Oil on canvas, 51 × 61
Private Collection

[27]

*Crème de Menthe, c.*1915

Oil on canvas, 107 × 84 · McLean Museum and Art Gallery, Inverclyde Council,
Stuart Anderson Caird Bequest 1948

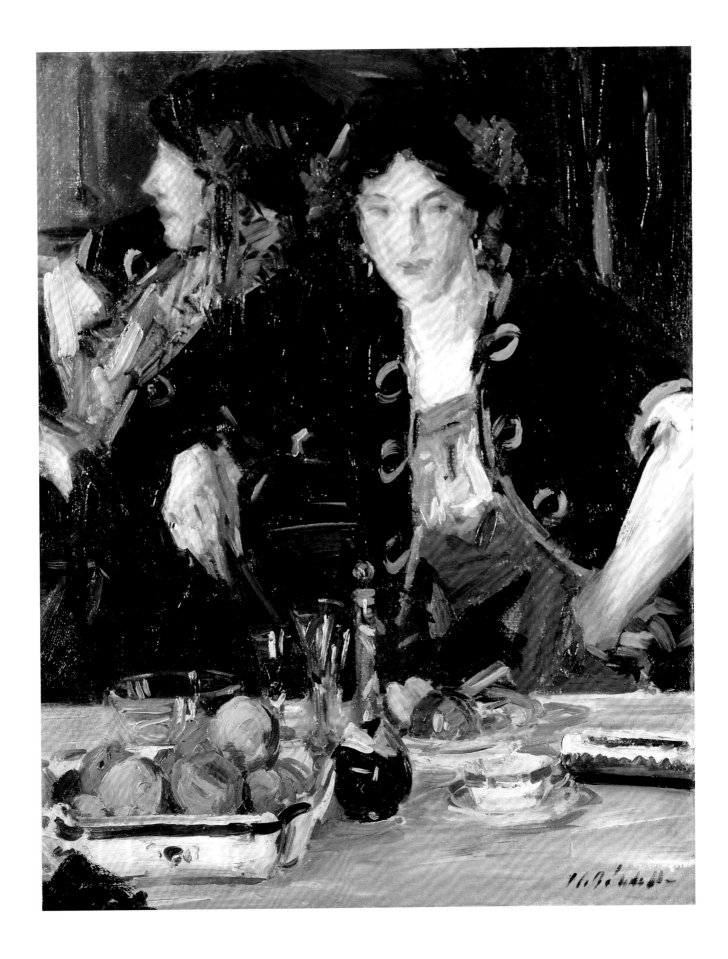

3 · PRIVATE CADELL

CADELL VOLUNTEERED immediately after the declaration of war in 1914, but was pronounced unfit. He gave up his pipe and worked on a farm at Kirkconnell, until he passed the necessary medical tests. He joined the 9th Battalion, The Royal Scots, as a Private in 1915. The battalion was formed from highlanders who lived in Edinburgh and was known as 'The Dandy Ninth'[29] as it was the only kilted battalion of this lowland regiment.[30]

Cadell was the only one of the four Scottish Colourist artists to fight in the war [29]. He served on the French front, was wounded twice and was awarded the General Service and Victory medals. Cadell captured aspects of life in the army and navy in a brilliant series of drawings executed in ink and watercolour before he was sent to the trenches. About fifty were shown in the Society of Eight's exhibition of 1915, whilst twenty were published by Grant Richards, London, in 1916 in a book entitled *Jack and Tommy* [31]. These witty, quickly executed images, depicting soldiers and sailors on duty and on leave, had titles such as 'Delicate Banter', 'Their Lordships' and 'Tommy and the Flapper'. The brisk, economic brush-and-ink technique of these drawings seems to have been based on illustrations Kees van Dongen made in the early 1900s, for journals such as *L'assiette au beurre* and *Gil-Blas*. Of the £100 Cadell made in sales from the exhibition, he donated almost half to the Scottish Branch of the Red Cross.

Jack and Tommy revealed Cadell's sympathy with the rank and file of the army. Until 1917 he resisted leaving the men with whom he had joined up, and only applied for a commission when he was told that he was shirking responsibility by not doing so. Cadell was commissioned as a 2nd Lieutenant in the 5th battalion of the Argyll and Sutherland Highlanders and returned to the front in April [30]. Amongst his personal

[28] Detail from 'The Air Ship' from *Jack and Tommy*, 1915
Scottish National Gallery of Modern Art, Edinburgh

papers is a dossier of portraits, mainly by Cadell, of the members of the 185th Tunnelling Company, Royal Engineers, with whom he served in France in July 1918, before being wounded. He depicted himself with a bottle of whisky in the background under the words 'Edinburgh's Folly.'[31]

Throughout the war, Cadell corresponded with Peploe who kept him abreast of events in Edinburgh, including the changes that James Paterson was making to Cadell's studio, which he was using whilst Cadell was on service.[32] He also sent him a copy of the new journal *Colour*, which featured work by Fergusson.[33] In a letter of 2 August 1918 Peploe lamented: 'I wish you were back in your studio ... I feel isolated here ... The price of paint is getting prohibitive ... Canvas almost unobtainable.'[34]

Whilst on service, Cadell wrote regularly to his sister Jean who was living in London and in one letter commented:

> *The very sound of England seems like heaven out here and people at home can have no conception of these hardships and discomforts or how marvellously easily they are got over ... Still it's a hell of a life and the sooner it's over the better for everyone.*[35]

Cadell was deeply upset on learning of the death of Ivar Campbell in Mesopotamia on 8 January 1916. Campbell was a Lieutenant in the 3rd Battalion of the Argyll and Sutherland Highlanders and died from wounds received in action. On his death, Cadell gave a portrait he had painted of Ivar seven years earlier to Ivar's mother Lady Sybil Campbell, with whom he remained friends for the rest of his life.[36]

Perhaps surprisingly, Cadell achieved significant professional success during the war, not least due to the efforts of Ted Stewart who managed his affairs in

his absence. For example, in 1917 he arranged exhibitions of Cadell's work at Doig, Wilson & Wheatley in Edinburgh and George Davidson's gallery in Glasgow, where it was seen by the dealer Alexander Reid. In 1889 Reid had founded his company La Société des Beaux-Arts, and opened a gallery in Glasgow, and did much to introduce nineteenth-century French art, including the Impressionists, to Scotland. Reid had already established close relationships with Peploe and Hunter and on 29 September 1917 he wrote to Cadell, stating:

> *For some time I have been much interested in your*
> *work and last year Peploe promised to take me down*
> *to the studio but you were only there at weekends.*
> *I should be very pleased to have some of your pictures*
> *if this were possible … I understand you are on service*
> *but possibly this may reach you and should you have*
> *time I should be glad to have a word from you.*[37]

Very soon afterwards Reid bought twelve paintings through Stewart and in November declared his desire to have 'first offer of any new work that Mr Cadell may do that is for sale'.[38] He held his first exhibition of Cadell's work in February 1918. With the backing of such an influential dealer, Cadell's career seemed to be assured and in his Register of Pictures he recorded an exceptional annual income for 1917 of £1,392 19s 10d.

Cadell rarely referred to the war and his gruelling experience of it in his work. Following his demobilisation in 1919 he returned to Edinburgh, but shortly afterwards sought succour on Iona. In June 1918 Peploe had written to him: 'I can see this habit of yours of living in dugouts must inevitably result in a new development in your painting. I see you will absolutely give up flake white.'[39] Peploe's prophesy was to be proved correct as Cadell's work soon underwent an abrupt and dramatic change.

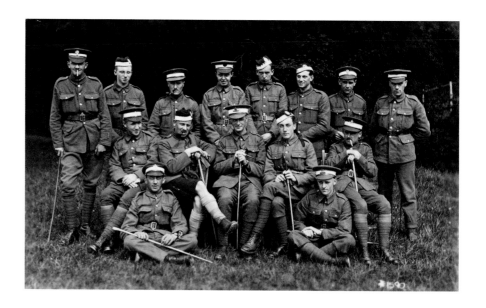

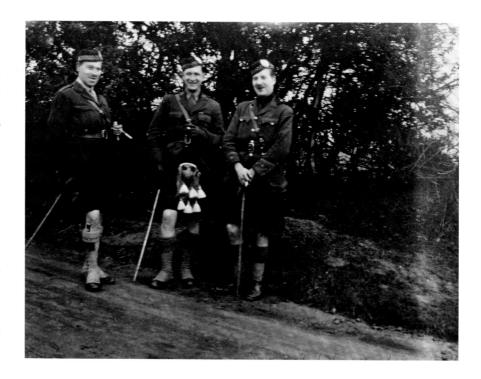

[29] Cadell (seated second from left) thought
to be on an officer cadet course, *c*.1918
Private Collection

[30] Cadell in uniform with fellow soldiers of
the Argyll and Sutherland Highlanders, 1918
Private Collection

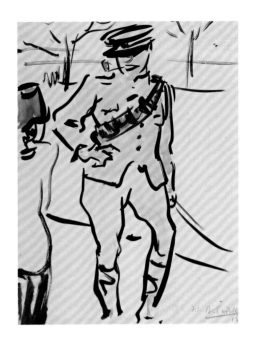

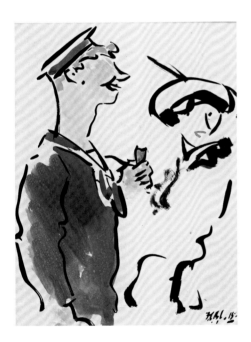

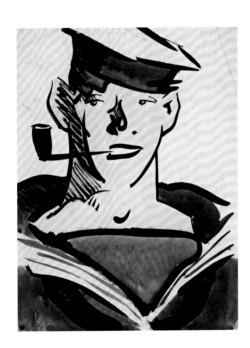

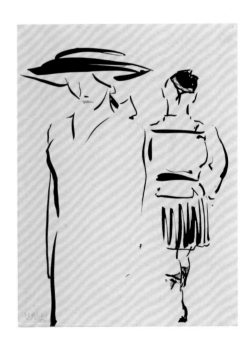

[31] These works come from the *Jack and Tommy* series of drawings that Cadell made in 1915. When a significant number were shown at the Society of Eight exhibition the following year they were widely praised. The critic of *The Studio* declared: 'The novelty of the Society of Eight Exhibition in their galleries in Shandwick Place was a series of clever cartoons of soldiers and sailors. About fifty in number, these bold sketches, in which, with a minimum of line in black, with sometimes a dash of colour introduced, a marvellous completeness of effect is produced.' (*The Studio*, vol.LXVII, 1916, p.59)

Top left to right:
'The Recruit', 'Jack and Tommy', 'Tommy and the Flapper'

Bottom, left to right:
'Delicate Banter', 'A Sailor', 'The Parting'

All works are ink and watercolour on card and measure approximately 43 × 34cm

Scottish National Gallery of Modern Art, Edinburgh

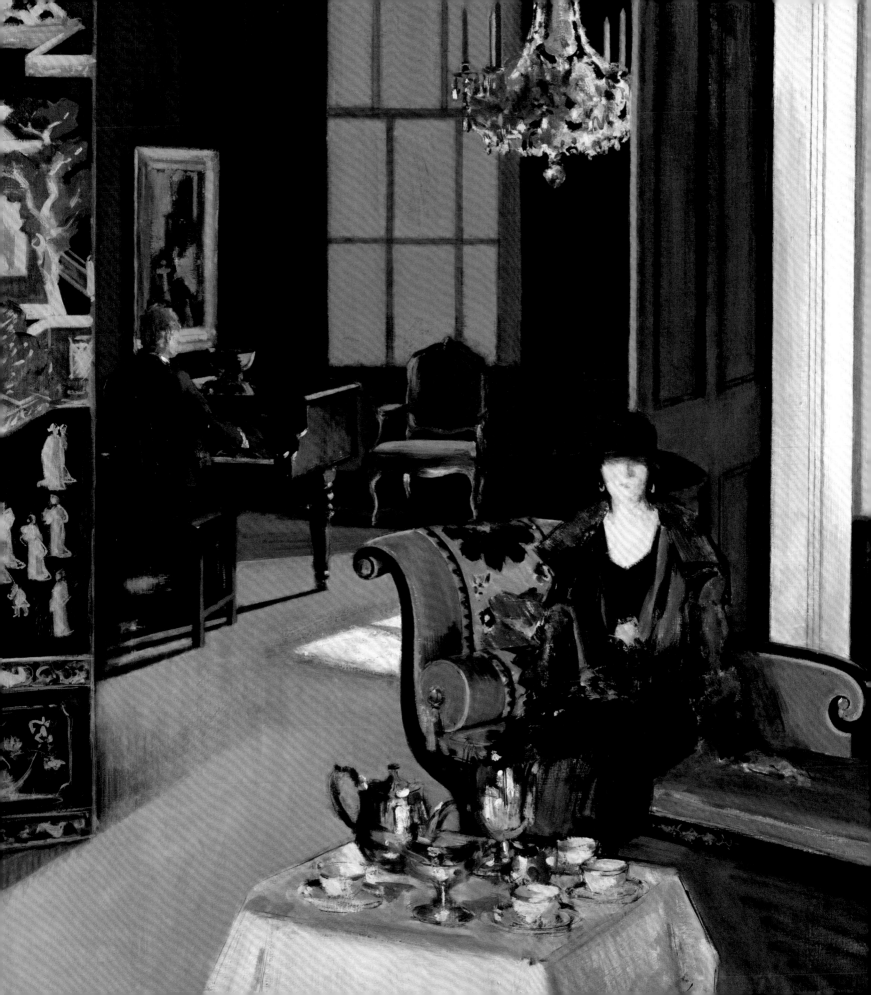

4 · AINSLIE PLACE

IN 1920 CADELL moved to 6 Ainslie Place [37], opposite his childhood home at no.22. It was one of the earliest properties in Edinburgh's Georgian New Town to be divided. Nonetheless, Cadell's quarters were magnificent and extended over four floors. The first floor had splendid front and back drawing rooms linked by double doors, the ground floor had an impressive front dining room and a large room at the back, the basement had the kitchen and house-keeper's room, and there was a sub-basement of service rooms, with a garden to the rear.[40] He painted his front door bright blue to annoy his neighbours.[41]

Cadell's eleven years at 6 Ainslie Place represent the summit of his personal and professional life. Cadell became established as a leading figure within Edinburgh society, known for his bold dress sense, unfailing humour, love of the good life and bountiful hospitality. His friend, the artist Stanley Cursiter described him thus:

> He was of middle height and robust build, he walked with a certain jauntiness of step – a straight and serviceable pipe gripped firmly in his teeth, an eye that lifted to a twinkle and a smile ready to expand to a quick laugh; careful in dress but seldom without a gay, distinctive note – shepherd tartan trousers – a blue scarf – a yellow waistcoat – or all the glory of his kilt, but with all, an air!...His wit was constant and brilliant.[42]

The practical running of his substantial home was undertaken by Charles Oliver, whom Cadell is believed to have met during the war. Tom Honeyman, who was a Director of Alex Reid & Lefèvre and became Director of Glasgow Art Gallery and who knew Cadell and Peploe commented: 'Come weal or woe, affluence or privation, Cadell refused to part with Charles, or it

may have been the other way about. Certainly Charles … was the complete expert in domestic affairs.'[43] However, Cadell himself took responsibility for the maintenance of his palette, as recalled by his patron Ion Harrison: 'At the end of a day's work he scraped every piece of paint off with his knife. He would then wash it thoroughly, and having dried it would burnish it and hang it up so that one could almost see one's face as in a mirror.'[44]

Cadell's stylish decoration of his home became the subject matter of a remarkable series of interiors painted in the 1920s [39, 40]. On the first floor, he repeated the lilac walls and the highly-polished black painted floorboards of his George Street studio. He added a brilliant lapis lazuli-coloured fire surround within the cream marble mantelpiece in the front drawing room. On the ground floor, walls and wood-work, including shutters, were painted in dark blue, green and brown above a light grey floor, whilst an impressive Robert Adam-style eagle overmantel partnered the black marble mantelpiece in the din-ing room.[45]

As with his George Street studio, furniture was kept to a minimum, but included his already familiar grand piano and the Louis xv-style armchair, a Chinese lacquered screen, a cabinet from the Edinburgh-based furniture designers Whytock & Reid's Chinese range, a Regency settee, chaise longue and chairs and a Georgian fire screen. The rooms were dressed with his own paintings, fine china, silver and glassware. Glamorous props, such as discarded opera cloaks, top hats, black fans, paintings leaning against the walls and lengths of brilliantly-coloured material draped over chairs, were added for pictorial effect [33]. He most frequently painted the view through the double doors of the two sets of main rooms, which opened

[32] Detail from *Interior: The Orange Blind* [60]

towards the front of the house. Those of the first floor are distinguishable by the parliament hinges which allowed them to be opened and folded back against the walls to create one large space, flooded with light from the three windows at the front and at the back, whilst those of the ground floor were met on either side by dado panelling, intended to protect the walls from the backs of chairs. Paintings of which he was particularly proud were depicted in later interiors, such as *The Blue Fan* [47] which can be seen in *The Opera Hat* [33].

The cropped compositions, flat application of paint and use of increasingly brilliant colour in these usually unpopulated works were in contrast to Cadell's pre-war interiors which are characterised by a looser handling, a cooler palette and which often feature elegant women. After the war, Cadell was no longer attempting to capture images of fashionable society, but instead was concerned with an almost abstract concept of space and perspective.

This marked change is thought to have been encouraged by Cadell's new surroundings, by his close collaboration with Peploe immediately after the war, by his interest in the Art Deco movement, and possibly in response to the squalor of the trenches. After Cadell's demobilisation in 1919, his friendship with Peploe intensified and their working relationship became closer. The same props can be seen in each other's work of this period, including one of the chairs that Cadell painted red which appears in Peploe's *Red Chair and Tulips* [34]. Peploe's *Interior with Japanese Fan* [35] also shows a common interest in the choice of subject matter as well as the positioning of the elements depicted, such as the props on the table and the material on the chair.

However, Peploe soon afterwards reverted to his preferred still lifes and Cadell continued to develop the genre of the interior. While Peploe's still lifes became more textured and coloured with subtle combinations of tones, Cadell's compositions became more geometric, his paint application more controlled and his colours increasingly acidic. In works like *The Blue Fan*, all shadow and volume is suppressed to create a hard-edged pattern of colour which embodies the Art Deco style. The term Art Deco derives from the celebrated *Exposition internationale des arts décoratifs et industriels modernes* held in Paris in 1925, but the style itself – the flattened, decorative forms, the vivid colour, the suppressed shadows, the geometric structure – was current in the early 1920s. Although Cadell visited Paris in 1923 and 1924, he did not have to go to France to encounter the key features of this new style as the taste for Art Deco spread around the western world through fashion magazines such as *Gazette du Bon Ton* and *Vogue*. Cadell's painting *Portrait of a Lady in Black* [49], which was exhibited in Glasgow in 1921 seems to show an awareness of illustrations by artists such as Georges Lepape and George Barbier. It has been said that a typical Art Deco picture should have such

[33] F.C.B. Cadell, *The Opera Hat*, 1923, showing *The Blue Fan* above the mantelpiece
Private Collection

[34] S.J. Peploe, *Red Chair and Tulips*, c.1919
Private Collection

[35] S.J. Peploe, *Interior with Japanese Fan*, c.1916
The University of Hull Art Collection, Humberside

a narrow depth of field that it could be peeled off the page like a transfer or a sticker, and Cadell's *Portrait of a Lady in Black* passes that test. However, Cadell's still lifes, such as *The Blue Fan* and *The Rose and the Lacquer Screen* [55] take the suppression of perspective and shadow a stage further and are rendered as blocks of unmodulated, pure colour. There are precedents in Art Deco painting and the lacquer work of Jean Dunand, but these still lifes are really Cadell's own creation, and count among the most remarkable paintings in British art of the period.

Changes in Cadell's art were also apparent, although to a lesser extent, in his contemporary figure studies. The woman depicted in his celebrated *Interior: The Orange Blind* [60] is probably Miss Don Wauchope, who had modelled for Cadell since before

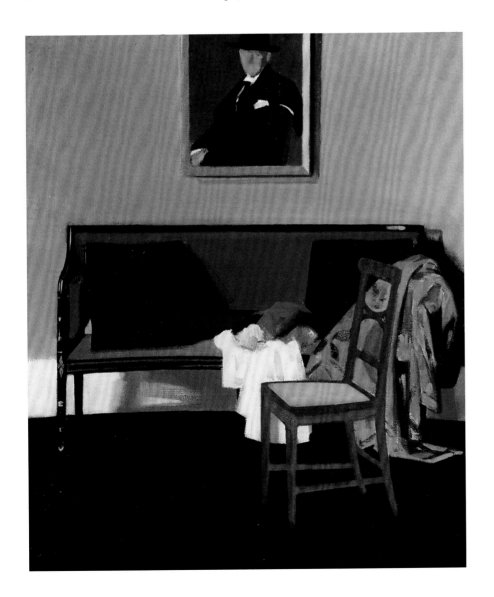

the war. She is believed to be the sitter in a series of 'Lady in Black' works of the 1920s [49, 50, 59]. In these paintings Cadell is still concerned with feminine sophistication and the suggestion of a glamorous lifestyle and Miss Don Wauchope is adorned in furs, gloves, hooped gold earrings and a large hat and is surrounded by expensive items of furniture. However, the dominant use of black, increasingly painted on flat, without modelling to suggest volume in either clothes or body, make these paintings more than images of a beautiful, stylish woman.

Cadell applied this approach to his rarer depictions of male sitters, as can be seen in his painting of the artist William 'Spanish' Macdonald [42], which is included in *Interior: The Red Chair* [36]. Macdonald was married to the painter Beatrice Huntington and they formed part of Cadell's and Peploe's circle of friends in Edinburgh. More radical, however, are Cadell's depictions of the male nude during this decade. Cadell had a keen interest in sport including boxing, rugby and football, although as a spectator rather than as a participant. One of his scrapbooks includes dozens of photographs of men locked in rugby tackles, wrestling holds and the like.[46] It is likely that he recruited models at sports events. In *The Boxer* [54], the stark simplicity of its design and the combination of the green wall, the red chair and the sitter's pale skin (in contrast to his sun-tanned face and hands), combine to make a strong image of masculine physicality, also seen in Cadell's paintings of Charles Oliver in red swimming trunks, on the beaches of Iona. Hanging on the wall in *The Boxer* is a head-and-shoulders painting of a black man who modelled for a series of bold, brightly-coloured paintings which Cadell began in about 1921, including *Negro (Pensive)* [53].[47]

Cadell's first recorded depiction of a black sitter in his Register of Pictures is a drawing dated 1915 and entitled 'Negro-nude'. This is some two to three years after the English artist Glyn Philpot's earliest known image of a black man, *Head of a Negro* of 1912–13. Philpot, who was well known for his paintings of black sitters, is listed in Cadell's address book, so they were evidently acquainted.[48] They were part of a growing movement interested in black culture, in the visual, literary and musical arts, which was a pronounced feature of the Jazz Age and the Art Deco movement. It was epitomised in the controversial anthology *Negro* edited by the shipping heiress and political activist Nancy Cunard and published in 1934.

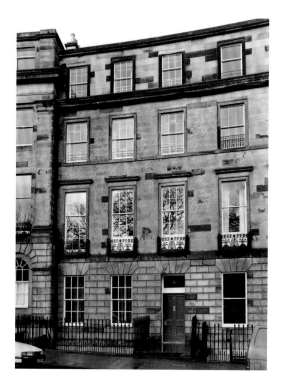

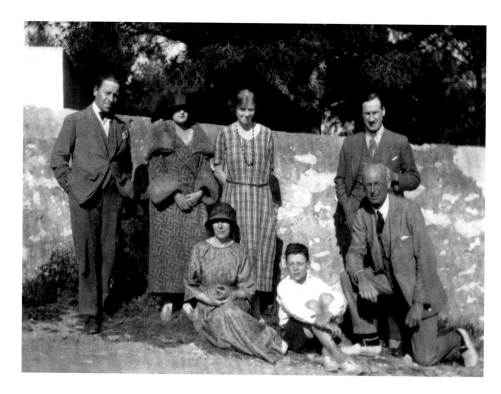

Cadell's interiors, figure studies and still lifes were painted in his studio, but during the summer months, usually spent on Iona, he preferred to paint out of doors. However, in 1923 he worked in Cassis, in the south of France, returning with Peploe, his wife Margaret and their sons Willy and Denis in 1924 [38]. The paintings he made in the south of France are bolder, in composition and palette, than the work produced on Iona. By the mid-1920s Cassis had become popular with artists. It was a small seaport, set in front of a ridge of limestone hills topped by a castle, with a picturesque, working harbour, charming side-streets and brilliant light.

Before arriving in Cassis in 1923, Cadell and Charles Oliver went to Amiens and visited the Somme Battlefields, before staying at the Château de Castelnau, near Nîmes, the ancestral home of the Boileaus, his mother's family.[49] Cadell then spent two months in Cassis, staying in the Hotel Panorama, from where he painted a series of images [43–6] and from where he wrote to George Chiene:

I find this part of France most interesting to paint. The light is wonderfully brilliant even fierce – the weather is superb – Basking! ... A very comfortable and cheap little hotel too. Charles is becoming quite proficient in the French language as he is having lessons 3 days a week! This place has several points in common with Iona. The colour and formation of headlands etc and to some extent the sea ... Instead of, as in Iona, painting against time and trying to get finished before the next squall of rain, I can work as long as I feel disposed on one thing.[50]

Although Peploe had painted in Cassis in 1913, the work he produced in 1924 was as uncompromising as that of Cadell. His family returned to Edinburgh before he did, and he wrote to Margaret:

Cadell and I get on very well and play billiards at night (tell Denis I beat him by four the other night) or go down to the Liautaud [Hotel] for a drink ... Cadell works away in his bedroom persistently; his work is painful to look at, and photographic in realism.[51]

The comment that the pictures were 'painful to look at' probably sprang from the intense brightness of Cadell's palette. Peploe's reaction was shared by others. The letters page of *The Scotsman* hosted a debate about the work he showed in the 1920 Society of Eight exhibition. Lady Constance Emmott complained about its 'flagrant vulgarity and insolent disregard of draughtsmanship ... These screaming farces in scarlet, bismuth pink, Reckit's blue, orange, with perhaps spaces in yellow, intended to indicate daffodils or

[37] Cadell's home and studio at 6 Ainslie Place, Edinburgh
Scottish National Gallery of Modern Art, Edinburgh

[38] Cassis, 1924, photograph taken by William Peploe. Left to right standing: Cadell, Mrs Penny, Jean Cadell, Captain Penny. Left to right seated: Margaret, Denis and S.J. Peploe
National Library of Scotland, Edinburgh

tulips, placed in jugs, the "drawing" of which any ... school child would be ashamed of.'[52]

In contrast, newspaper critics singled Cadell out for praise in the landmark exhibition *Paintings by S.J. Peploe, F.C.B. Cadell and Leslie Hunter* held at the Leicester Galleries in London in 1923. It was organised by Alexander Reid's son, A.J. McNeill Reid, who conceived the idea of showing the three artists together in a dedicated exhibition. Cadell showed thirty works and the *Daily Mail* review summed up the difference between his pre- and post-war work, stating:

> *[In his earlier work] he retained the freshness of his vision at the expense of "finish" and was apt to leave his pictures in a state of summary sketchiness which almost amounted to flippancy. He ... has solidified his style. All forms are now stated with an assurance of rightness that carries conviction. He has passed from the vague impression to architectonic organisation.*[53]

The Reids did much to promote the work of the artists now known as the Scottish Colourists by putting on joint exhibitions in London and Paris. In 1923 Alexander Reid held his first exhibition of the work of Fergusson and in 1924, he decided to show him alongside Cadell, Peploe and Hunter at the Galerie Barbazanges in Paris. The gallery stood on the fashionable Rue du Faubourg Saint-Honoré, in a building owned by the couturier Paul Poiret, a keen collector of modern art. The exhibition went under the title *Les Peintres de l'Ecosse Moderne* and was the first time the four artists were presented as a group. It was opened by the Marquis of Crewe, who purchased a Cassis painting by Cadell.[54]

In 1925, McNeill Reid organised a second exhibition of the work of the four artists at the Leicester Galleries. Walter Sickert wrote the catalogue introduction and declared of Cadell:

> *Perhaps the most important modernist triumph of today is the assertion of hardness as an ideal in place of softness ... Mr Cadell is hard and I glory in his hardness. Mr Cadell's execution may be called 'tea-tray' – so was that of Ingres and Karel du Jardin! It is perhaps superfluous to beseech a Scot not to budge an inch!*

A further exhibition, *Les Peintres Ecossais*, was held in Paris in 1931. It also included work by the artists George Telfer Bear and Ronald Ossary Dunlop, and was staged at the Galerie Georges Petit. The French state acquired paintings by Fergusson, Hunter and Peploe from the exhibition, but nothing by Cadell. Following Hunter's death in 1931, McNeill Reid selected work by Telfer Bear and the young William Gillies to join that of the four 'Colourists', in an exhibition entitled *Six Scottish Artists* held at Barbizon House, Cavendish Square, London in 1932. Barbizon House was the gallery of the Edinburgh-born art dealer David Croal Thomson, which was taken over by his son Lockett Thomson following his father's death in 1930.

Cadell's work was exhibited regularly and widely throughout the 1920s, most significantly in seven solo exhibitions organised by the Reids in Glasgow between 1921 and 1928 and in the representation of his work at the annual Society of Eight exhibitions. Cadell also sent regularly to the Royal Scottish Academy and the Royal Glasgow Institute. His highest recorded annual income was of £2,425 6s 4d in 1922, with major acquisitions being made by the Misses Mary and Jane Rough of Edinburgh, Patrick Ford, A.J. McNeill Reid, George Chiene and the Edinburgh accountant and collector John James Cowan. However, despite this professional success, Cadell was beset by financial problems throughout the decade. This was in no small part due to his lavish lifestyle, but was also linked to the gradual decline of the British art market as the country's economy fell into recession. The General Strike of 1926 and the Wall Street Crash of 1929 marked the beginning of a period of economic depression which lasted throughout the 1930s. This was especially the case in the industrial west coast of Scotland where many of Cadell's major patrons were based.

A feature of Cadell's professional life was his independent selling of work. In a letter of 1925 to his patron, the Fife-based paper manufacturer David Russell, Cadell referred to his recent Leicester Galleries exhibition:

> *I have been writing to a few people who were obviously interested in my show of pictures, but who did not buy and my reason for doing so is as follows. The exhibition being now over, the unsold pictures are going for exhibition to my Glasgow dealer, who in common with all other dealers charges 25% commission on sales. I therefore am offering the pictures, before their departure at 25% reduction on the catalogue price.*[55]

Cadell also held selling exhibitions of his work at 6 Ainslie Place, in 1925 and 1926. He wrote once more

to Russell, stating: 'The picture market is so bad just now that I have determined to write privately to people interested in my pictures, offering them this opportunity of buying my work at half its original price.'[56] Cadell's Register of Pictures records that he even consigned pictures for sale at auction in 1924 and 1925. But by 1928 the situation had deteriorated further. McNeill Reid commented on Cadell's solo exhibition of that year:

> *Your Show has, unfortunately, turned out to be the least successful Exhibition I have ever held in our place and the net sales to date amount to £10 ... I do not know what is happening in Glasgow as an Art centre now, whether it is lack of money, or lack of interest – probably both. Everybody seems to be complaining and the [Royal Glasgow] Institute has, I understand, experienced the worst season for many years past.*[57]

Cadell found himself with no alternative but to sell his home. It was bought by his upstairs neighbours Mr and Mrs Arthur Ramage and Cadell, in turn, bought their property which consisted of the two more modest top floors of 6 Ainslie Place, originally intended as bedrooms, nurseries and servants' quarters. It is notable that Cadell did not paint the stunning view from the front over the city of Edinburgh, or that from the back over to the Firth of Forth. In 1931, he staged an ambitious exhibition of ninety works at Parsons' Galleries, 54 Queen Street, Edinburgh, but this generated sales of just £95. Also in that year he was finally elected an associate of the Royal Scottish Academy. After failing to be elected twice, he had taken his name off the waiting list just after the war, refusing to allow it back on until 1931.

Throughout the 1920s, the ever-loyal and patient Ted Stewart, now a solicitor with the firm of Murray Beith & Murray, attempted to sort out Cadell's finances, including his income tax. As T.J. Honeyman commented: 'to criticise his irresponsibility was easy; to quarrel with him was impossible'.[58] However, despite Stewart's best efforts, in 1931 Cadell was again forced to sell his home to contribute towards paying off his debts, thus leaving 6 Ainslie Place and finding himself homeless once more.

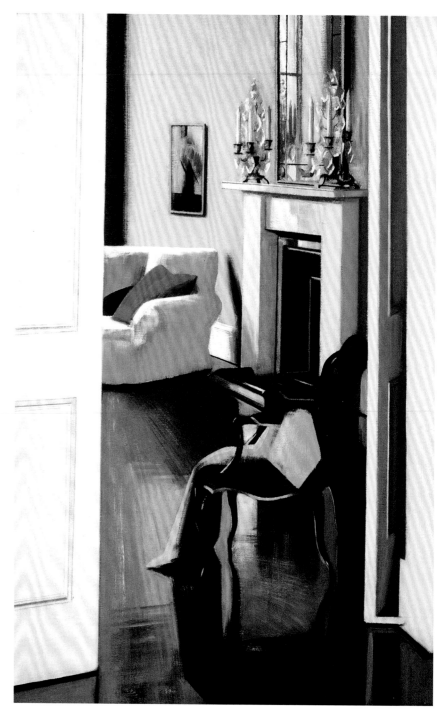

[39]
Interior, early 1920s
Oil on canvas, 76.2 × 50.8
Scottish National Gallery of Modern Art, Edinburgh,
on loan from a private collection

[40]
*The Gold Chair, c.*1921
Oil on canvas, 60.9 × 50.8
Private Collection

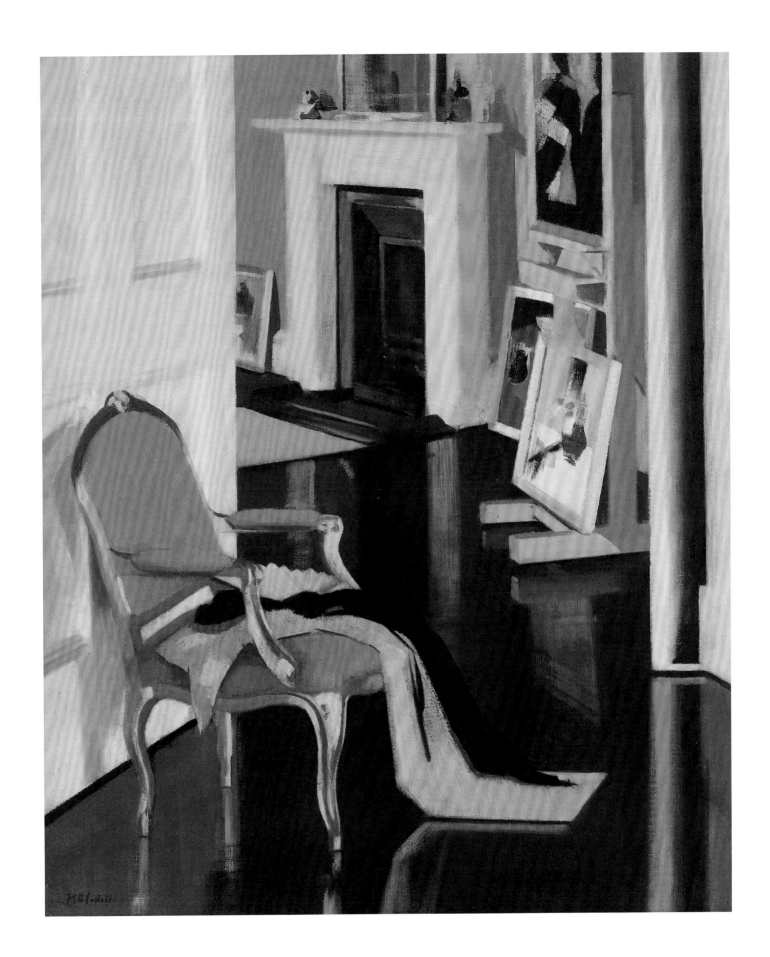

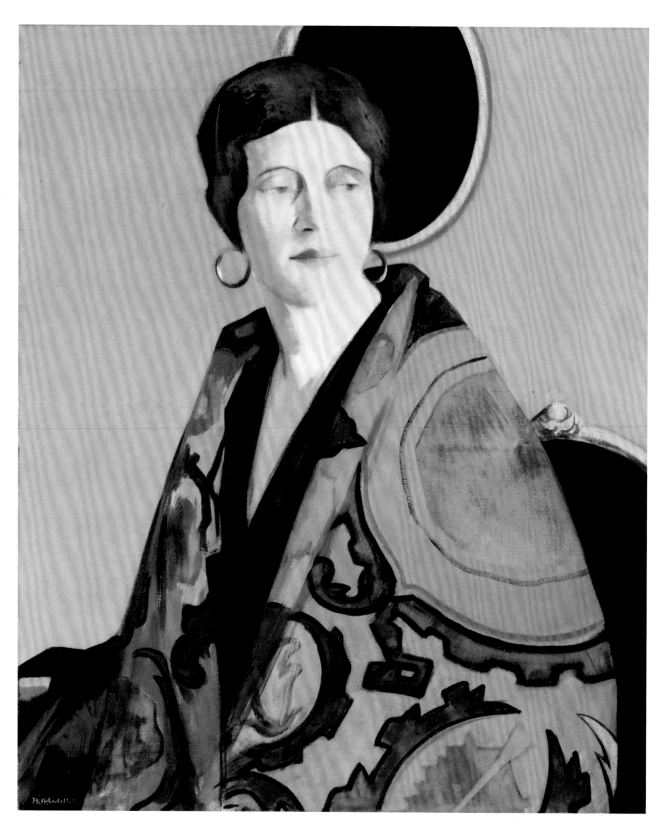

[41]

*The Embroidered Cloak, c.*1922

Oil on canvas, 74.3 × 61.6
Ferens Art Gallery, Hull Museums

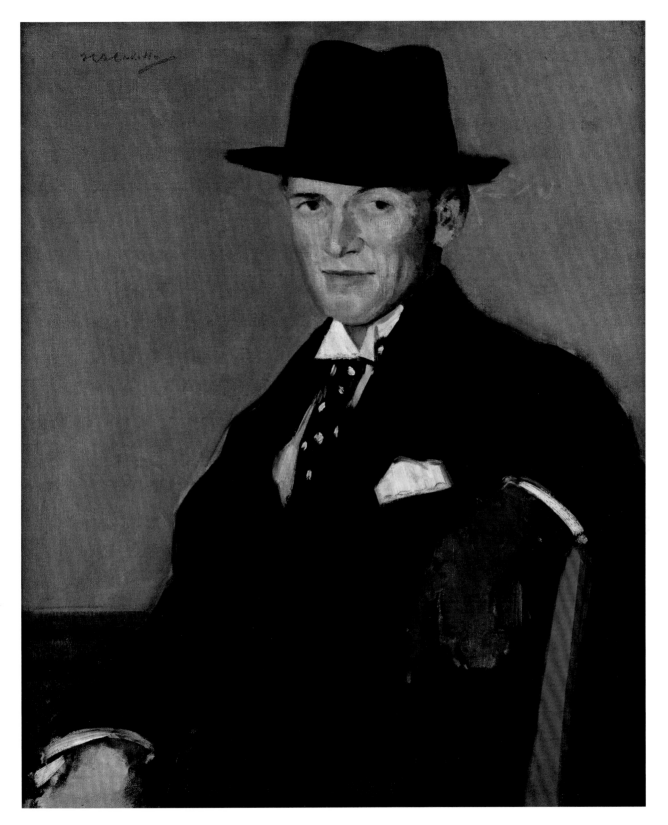

[42]

Portrait of a Man in Black (*William Macdonald Esq*), mid-1920s

Oil on canvas, 76.3 × 63.6
Private Collection

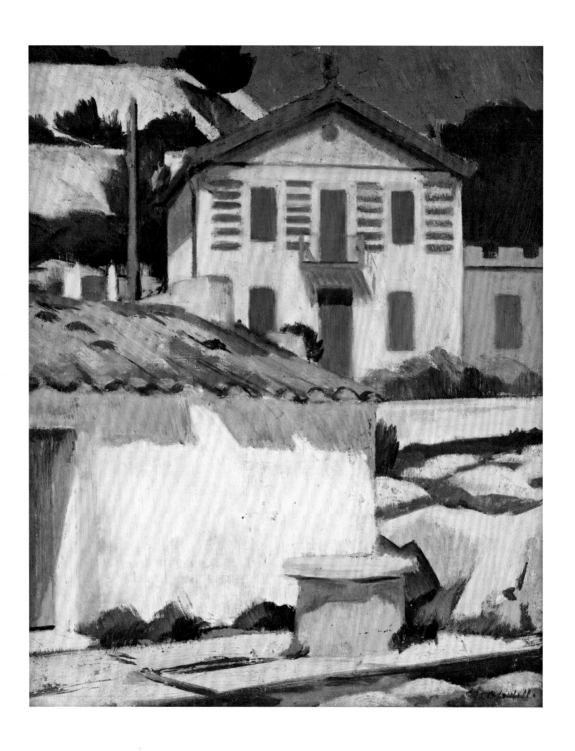

[4 3]
Green Shutters, Cassis, 1923/24

Oil on panel, 45 × 37
Private Collection

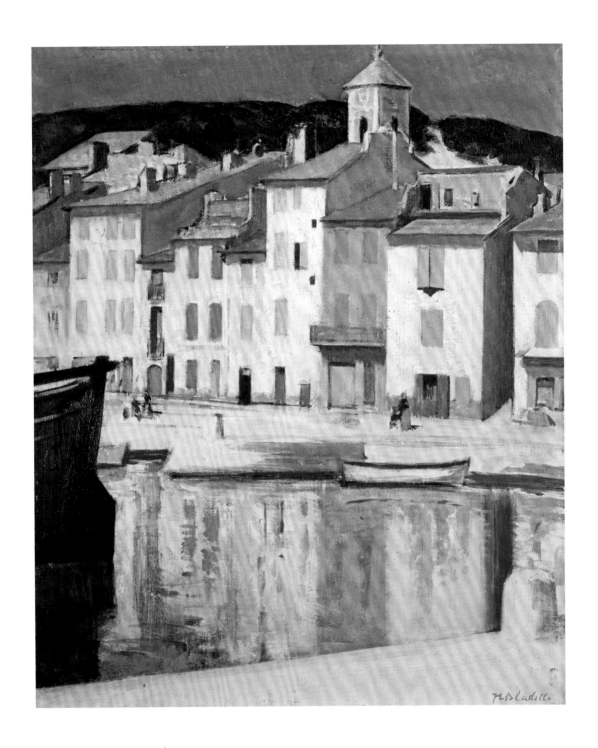

[44]

The Harbour, Cassis, 1923/24

Oil on panel, 44.8 × 37.2
Private Collection

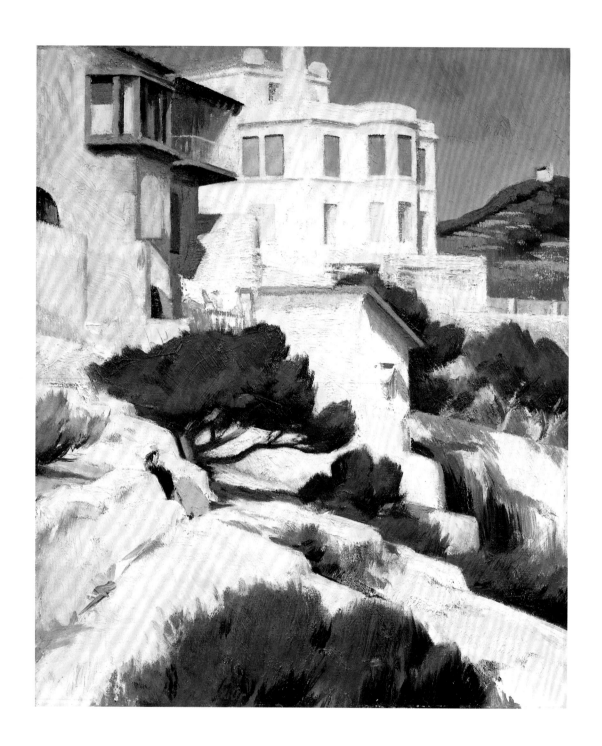

[45]

Cassis, 1923/24

Oil on panel, 45 × 37.5
Private Collection

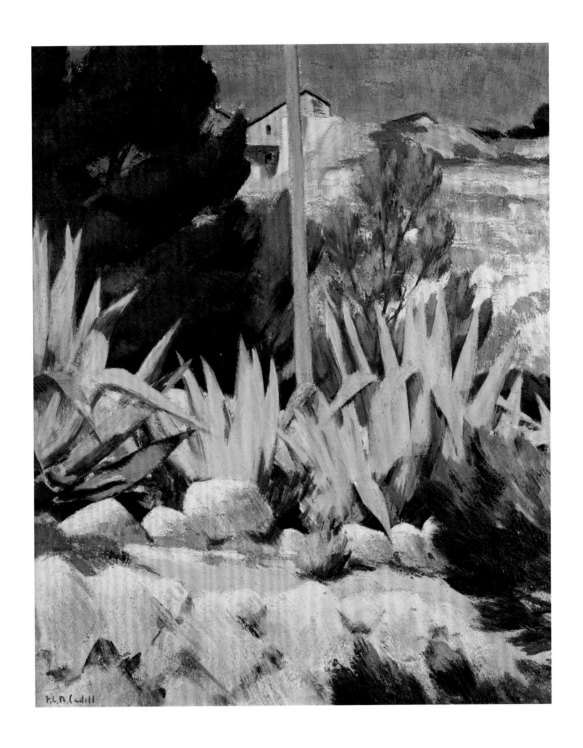

[46]

Cassis – The Quarry, 1923/24

Oil on panel, 45 × 37.5
Private Collection

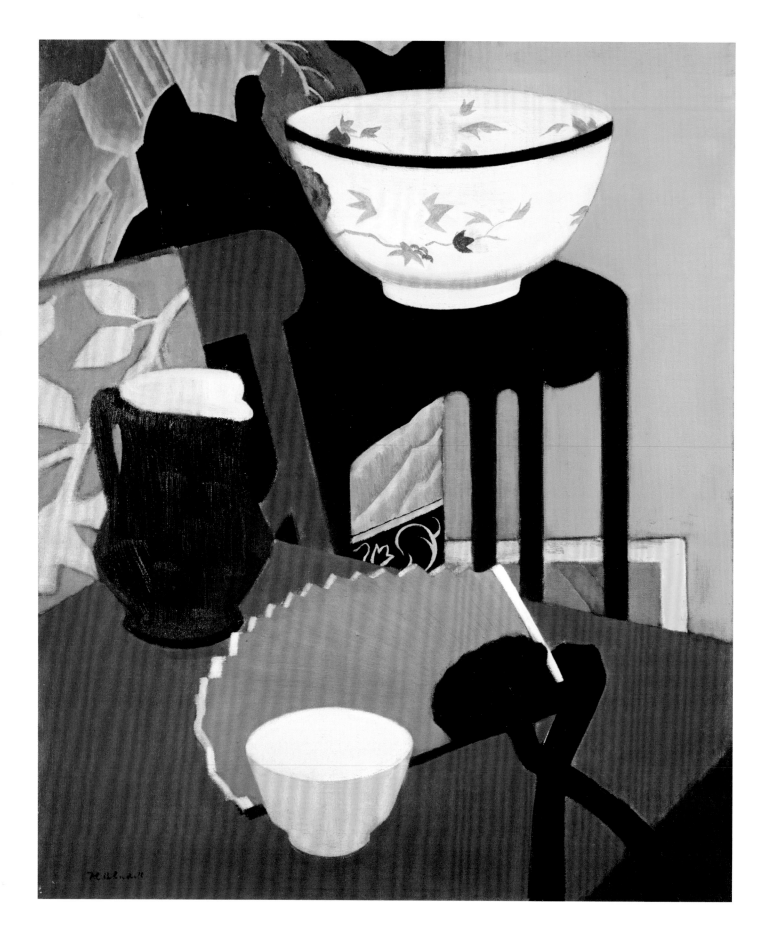

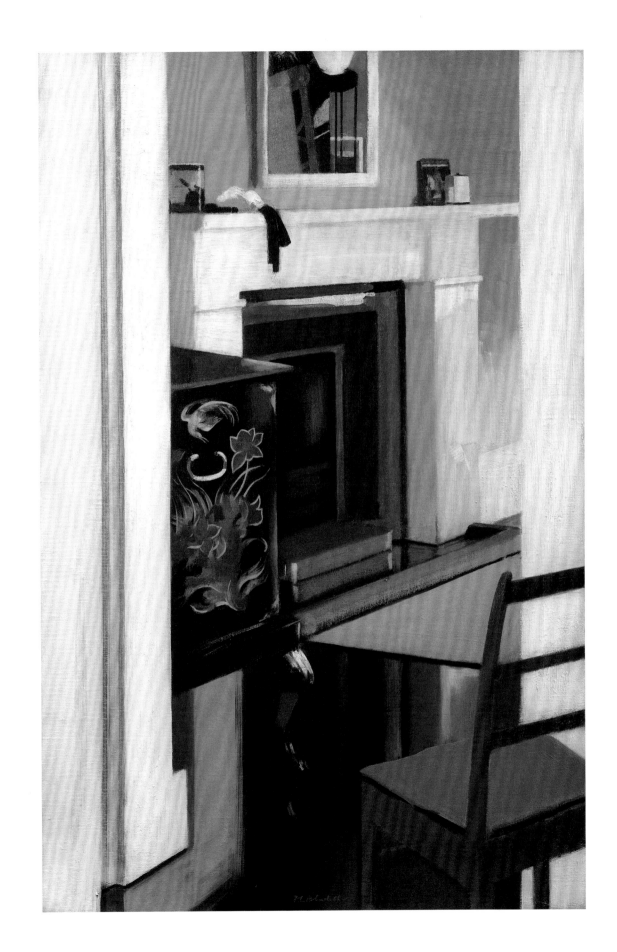

[47]
The Blue Fan, early 1920s

Oil on canvas, 61 × 50.5
Scottish National Gallery
of Modern Art, Edinburgh, bequeathed
by Dr James Ritchie 1998

[48]
Interior: The Red Chair, early 1920s

Oil on canvas, 75.9 × 51.1
Richard Green Gallery, London

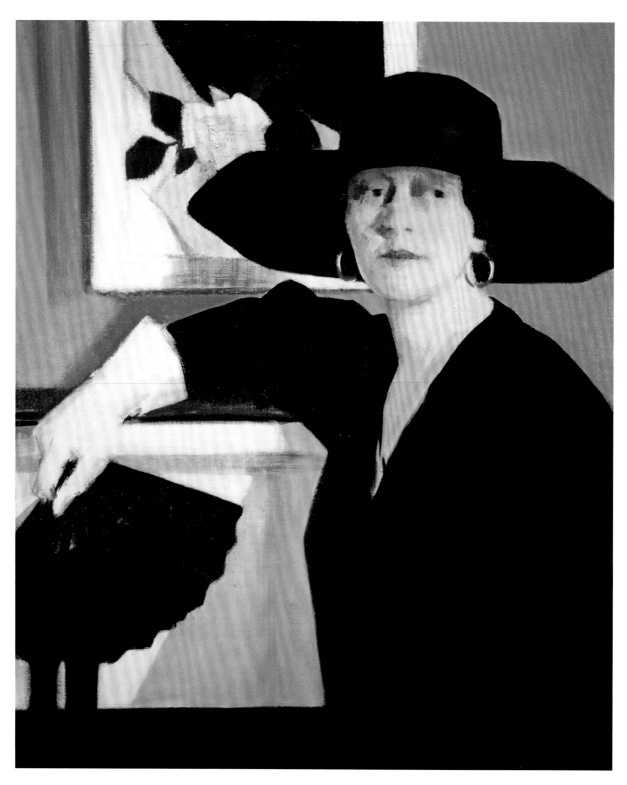

[49]

*Portrait of a Lady in Black, c.*1921

Oil on canvas, 76.3 × 63.5 · Scottish National Gallery of Modern Art, Edinburgh,
bequest of Mr and Mrs G.D. Robinson, through the Art Fund 1988

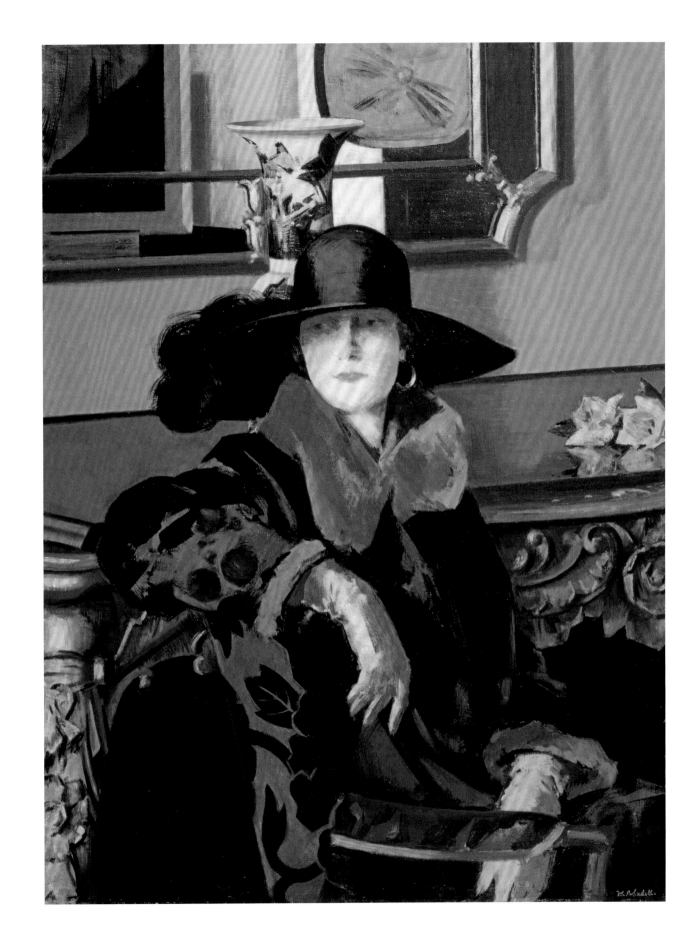

[50]

*A Lady in Black, c.*1925

Oil on canvas, 101.6 × 76.2
Culture and Sport
Glasgow (Museums)
Kelvingrove Art
Gallery and Museum,
purchased 1926

[51]
Aspidistra and Bottle on Table, mid-1920s

Oil on canvas, laid on board, 76.2 × 60.9
Scottish National Gallery of Modern Art, Edinburgh,
bequest of Mr and Mrs G.D. Robinson through The Art Fund 1988

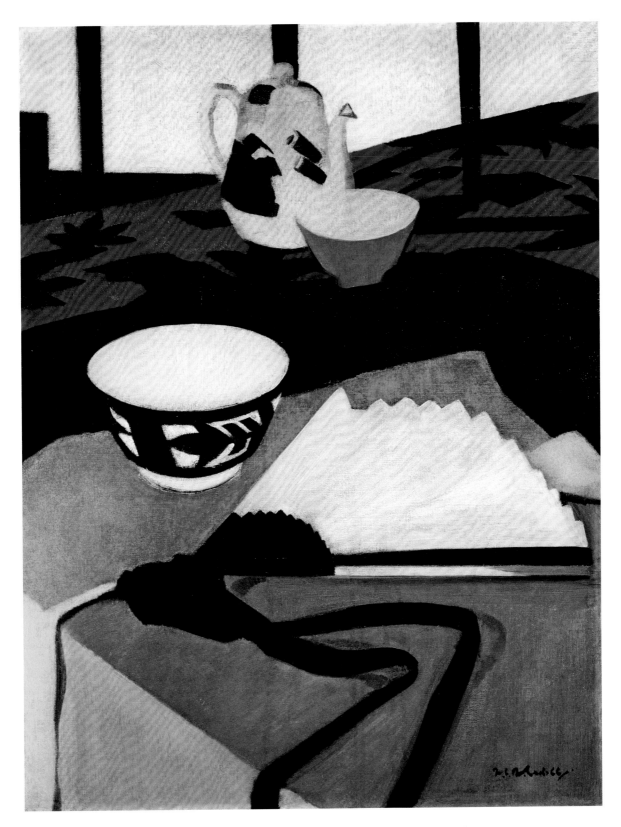

[52]
Still Life (The Grey Fan), early 1920s

Oil on canvas, 65.5 × 49.6
Scottish National Gallery of Modern Art, Edinburgh

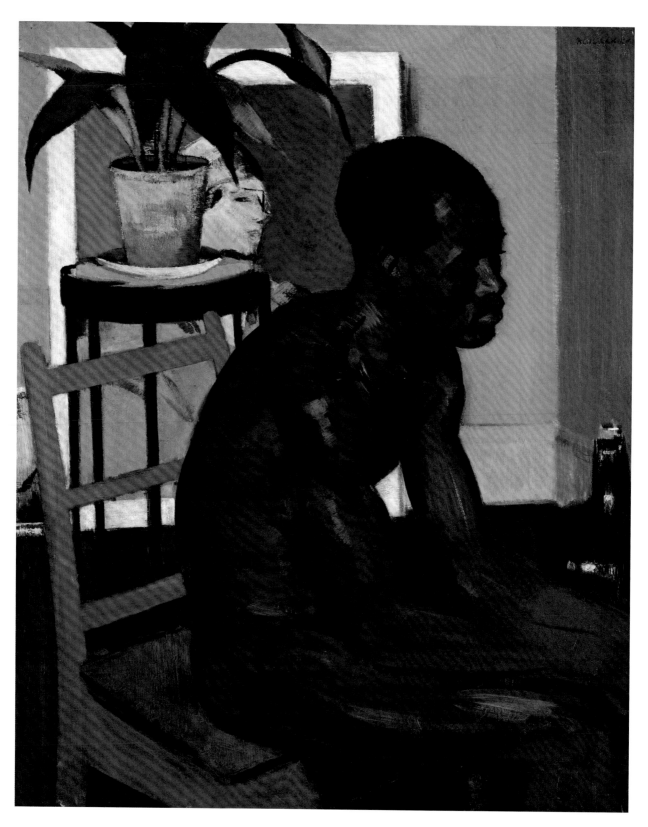

[53]

*Negro (Pensive), c.*1922

Oil on canvas, 76.6 × 63.9
Private Collection

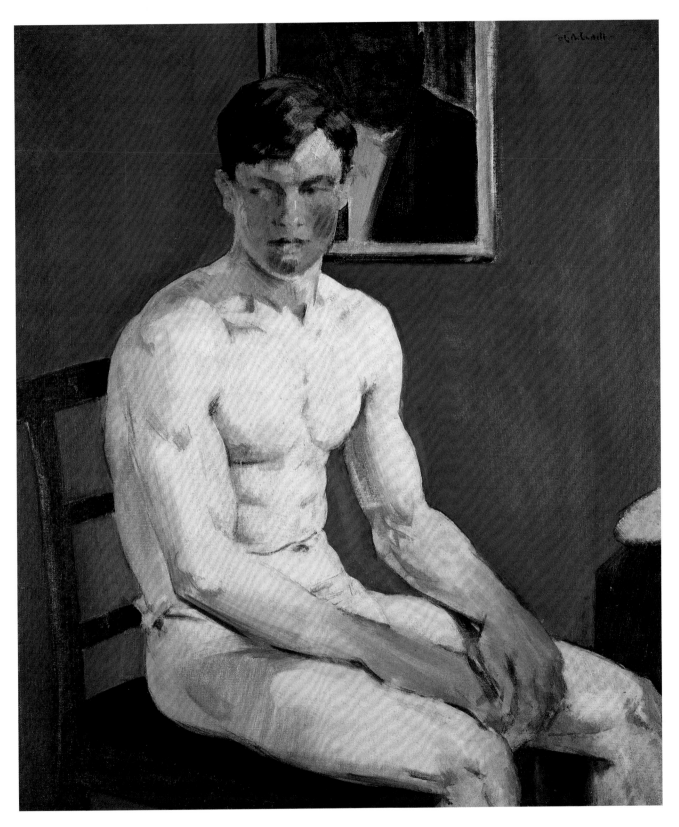

[54]

The Boxer, mid-1920s

Oil on canvas, 76.2 × 63.5
Private Collection

[55]

The Rose and the Lacquer Screen, early 1920s

Oil on panel, 45 × 37

Scottish National Gallery of Modern Art, Edinburgh, on loan from a private collection

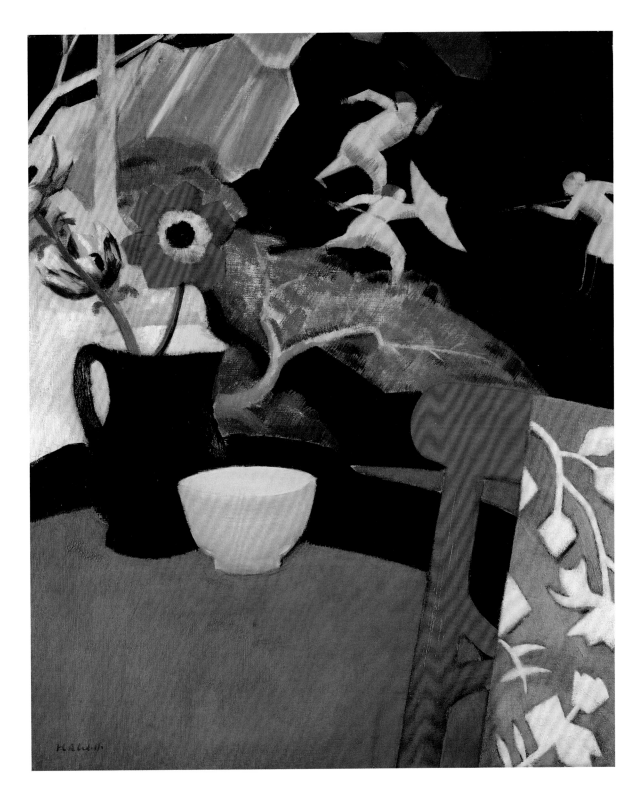

[56]

Still Life with Lacquer Screen, mid-1920s

Oil on canvas, 59.4 × 49.5
Private Collection

[57]

Roses, late 1920s

Oil on panel, 45.7 × 38.2
Private Collection

[58]

The Pink Azaleas, c. 1924

Oil on canvas, 61 × 46
Private Collection

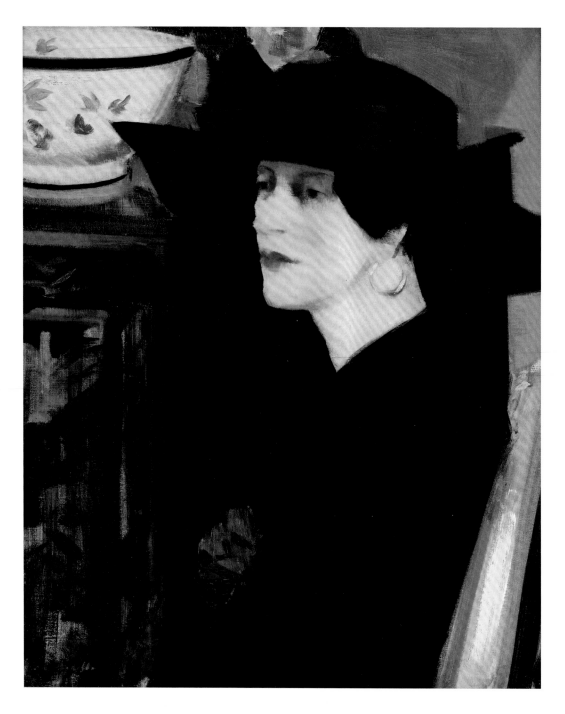

[59]
The Black Hat, mid-1920s

Oil on canvas, 61 × 51
The Ellis Campbell Collection

[60]
*Interior: The Orange Blind, c.*1927

Oil on canvas, 112 × 86.5
Culture and Sport Glasgow (Museums) Kelvingrove Art Gallery and Museum,
presented by the Trustees of the Hamilton Bequest 1928

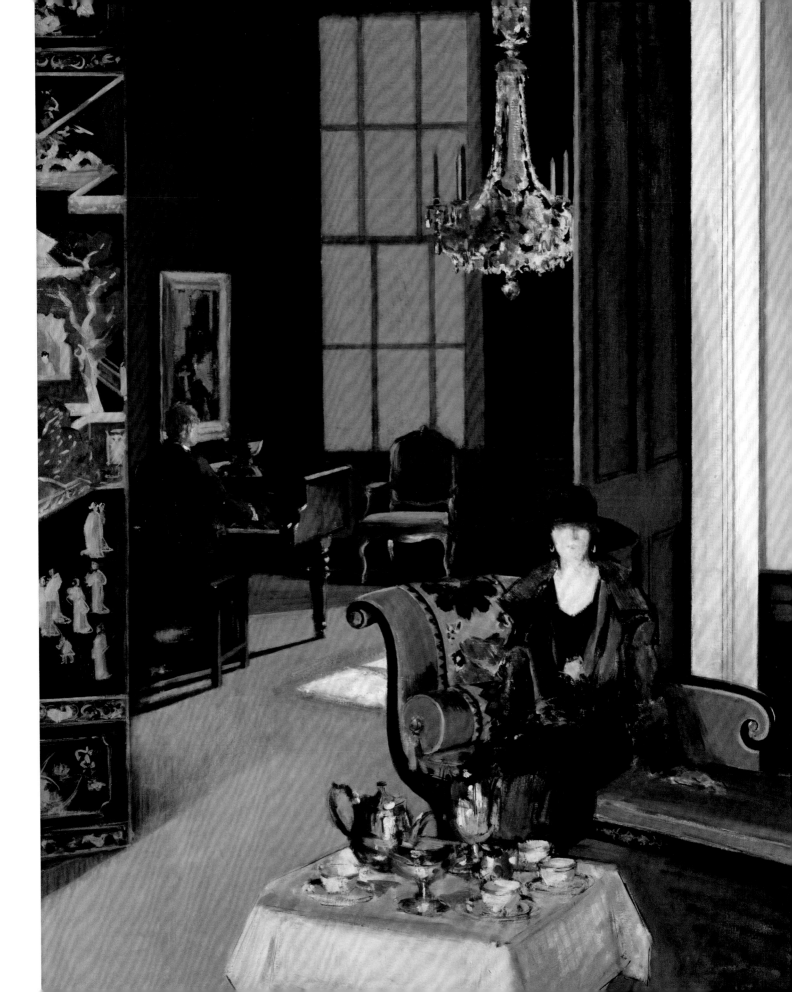

5 · THE LATER YEARS AND CADELL'S LEGACY

IN 1931 CADELL TURNED to friends and relations for accommodation, painting works for them in return, just as he had done during the 1900s. For example, before he moved to his new home at 30 Regent Terrace in 1932, he stayed with his patron Miss Wood in Edinburgh and with Ivar Campbell's mother Lady Sybil Campbell in Argyll, where he painted a series of interiors of her home [65].

On settling into Regent Terrace, a fine Regency property (albeit not in the more desirable New Town) which he rented for £100 a year, Cadell wrote to David Russell: 'I am very pleased with my new house which has a lovely view of Holyrood and Arthur's Seat. It is still unfurnished, so if you do turn up you mustn't mind the muddle.'[59] A work of 1933, *Interior: The Open Window,* shows part of the view that he refers to, and also one of Cadell's paintings of the white villa in Cassis hanging on the wall. This work exemplifies Cadell's late style: the predominance of black remains and is now used increasingly to outline features, while his technique is less structured and his colours are more sober.

In 1928 Cadell met the Glasgow shipowner Ion Harrison, who had purchased his first Cadell through Alexander Reid in about 1925. Harrison and his wife, Marie-Louise, became major patrons, especially in the last years of Cadell's life. Harrison recalled that when the artist first visited him at home and saw his painting *The Pink Azaleas* [58] Cadell declared: 'I have often wondered where that picture went. I congratulate you on having acquired it and although I say it myself you have a damned good Cadell', and broke into his infectious laugh.[60] Cadell explained to Harrison the benefits of buying work by living artists, declaring:

The advantage in buying modern pictures is [1] that the buyer knows the work to be by the artist who paints it; [2] buying comparatively low, with the sporting chance, combined with either knowledge or luck, that the pictures will go up, and [3] the advantage – and this to the painter – of encouraging contemporary art without which there would be no future 'old masters'.[61]

Harrison took his words to heart and commissioned two interiors of his home for which he paid £105 [66] and two portraits of his wife, that Cadell painted during extended stays with them [67]. The portraits show a significant development from Cadell's images of Miss Don Wauchope of the previous decade: detail, texture and modelling have returned, along with pronounced brushstrokes and layering of colours.

Exhibitions of Cadell's work were held at The Scottish Gallery in 1932, the first with them since 1922, and at Pearson & Westergaard in Glasgow, in 1933 and 1934 (they had taken over his interests after the closing of Alexander Reid's gallery in 1932). Having carefully maintained his Register of Pictures for over twenty years, Cadell now resorted to basic notes written on sheets of paper.[62] His total annual income for 1931 was a mere £290. Once again, Cadell wrote directly to his patrons, offering them work at discounted prices. He wrote to Russell declaring: 'In case you would like to give yourself a "bon marché" Cadell for a Christmas present, I write to let you know that I am selling my old panels 18 × 15" for £10 each and my watercolours for £4 framed. The pink roses you admired in Iona are still available as are (alas) many others.'[63]

Cadell's financial position deteriorated further in

[61] Detail from *Carnations*, 1934
Oil on panel, 28.5 × 21.5
Private Collection

step with the continuing decline of the art market and his failing health. David Russell suggested a commission to design advertisements for three types of paper produced by his mill, but Cadell failed to fulfil this.[64] In 1935 Cadell was forced to move again, this time to a flat at 4 Warriston Crescent, near Edinburgh's Royal Botanic Garden. He appears, however, to have kept his sense of humour and in his 1936 entry for *Who's Who*, described his recreation as 'Bed and billiards'.[65] In 1935 Peploe died. Ion Harrison recalled: 'At the graveside Cadell was so distressed that he had to walk away from the mourners.'[66]

Ironically, and despite various setbacks, Cadell's official standing grew in the final years of his life. Several works entered public collections, including the figure studies *Pink and Gold*, which was presented to Paisley Museum and Art Gallery by Miss M.K. Muir McKean in 1932 and *Black and Gold*, which was purchased by the Trustees of The Stuart Anderson Caird Bequest from the Royal Scottish Academy in 1934 for the McLean Museum and Art Gallery in Greenock. In 1935 Cadell was elected to the Royal Society of Watercolours and in 1936 he was finally elected a Royal Scottish Academician [62]. Six months later he applied to the Academy's Alexander Nasmyth Fund, which was established to help 'decayed Scottish Artists'. On the application form he answered the question 'To what cause or causes do you attribute your present difficulties?' with the reply 'Failure of purchases – death of Patrons, and difficulties in connection with my house in Ainslie Place – since disposed of.'[67] Sales from the 1935 Society of Eight exhibition added up to £161 19s 0d, but he still remained in debt to Murray Beith & Murray to the sum of £81 7s 8d.[68]

Cadell's last years were dogged by ill-health, caused by accidents, including falling down the stairs of a tram and a mugging whilst walking home one evening, and what was finally diagnosed as cancer.[69] On one occasion he walked several miles to the artist William Caldwell Crawford's home, Erraid House in Lothianburn, to ask for help. He was so dishevelled Mrs Crawford would not allow him in, although he was permitted to sleep in his friend's studio in the grounds for a couple of nights.[70]

Cadell's health worsened and on coughing up blood in front of his sister Jean, he quipped 'My goodness, my Guinness'.[71] In November 1937 Cadell underwent an operation to remove a tumour but died in a private nursing home at 22 Moray Place on 6 December

1937. His death certificate states the cause of death as cancer and cirrhosis of the liver.

Cadell was only fifty-four years old when he died. He was buried in the Dean Cemetery in Edinburgh alongside other members of the Cadell family including his father and his mother. His will stated: 'Except family portraits and silver which I bequeath to Jean and Gruff [Jean's son], I leave everything to Charles Oliver, my most faithful friend.'[72] Oliver stayed in touch with John Cadell for many years to come, through intermittent requests for money.[73] Cadell's estate was valued at £495 and an uncashed cheque

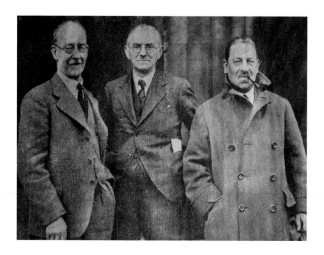

for £50 from the Alexander Nasmyth Fund was found amongst his effects.[74] His sister Jean and Ted Stewart acted as Executors.

The Royal Scottish Academy mounted a memorial exhibition of Cadell's work in 1938, as did the National Gallery of Scotland in 1942. The latter exhibition was organised by his friend Stanley Cursiter and toured to Glasgow Art Gallery. This was an exceptional recognition of Cadell's achievements given that the National Galleries of Scotland then had a policy of not acquiring or displaying work by any artist who had been dead for less than ten years. However, neither Reid & Lefèvre (the amalgamation of Alexander Reid's company and The Lefèvre Gallery of London) nor The Scottish Gallery followed suit. For a man whose lifestyle and art had once been so fashionable, Cadell's painting now seemed out of step with the various movements that had been developing since the 1920s, including Constructivism and Surrealism.

A certain number of Cadell's works entered public collections during his lifetime. The first sales to public

institutions were two drawings, *Seated Ballerina* and *Cecilia*, which were bought from the Venice International Exhibition in 1914 for the city's collection and are now held at Ca' Pesaro: Galleria Internazionale d'Arte Moderna. In 1917, a portrait sketch of Lady Lavery was donated to The Scottish Modern Art Association. This philanthropic organisation was established in 1907 to collect contemporary Scottish art for the enrichment of Scottish public art collections and its acquisitions were donated to the city of Edinburgh in 1964.[75] On the front page of the address book which Cadell began in 1929, he kept a list of his works being acquired by or being given to municipal collections. This was also reflected in his Register of Pictures, in which can be found entries for *A Lady in Black,* purchased for £180 at the Royal Glasgow Institute in 1926 by the Corporation of Glasgow for the art gallery at Kelvingrove [50] and *Interior: The Orange Blind* [60], purchased for £150 from the Royal Glasgow Institute exhibition in 1928 by the late Mr John Hamilton's Trustees, for presentation to the City of Glasgow. During the 1930s, works by Cadell entered several public collections including those of Dundee, Greenock, Manchester, Rochdale and Paisley. The first work to be acquired for Scotland's national collection was *The Model* [16] in 1947.

Between 1942 and The Fine Art Society's touring centenary exhibition of 1983, no solo exhibitions of Cadell's work were mounted. However, he was represented in exhibitions dedicated to various groupings of the Scottish Colourists. A monograph devoted to Cadell's work was not published until Tom Hewlett's book of 1988, which accompanied a selling exhibition held in London and Edinburgh. Ironically, given his financial troubles, Cadell's place in the art market is more secure than it is in art history.

All four Scottish Colourists are credited with influencing the generation of artists who came to prominence in Edinburgh after the war, including William Gillies – who exhibited with them at Barbizon House in 1932 and became a member of the Society of Eight – John Maxwell, William MacTaggart (the grandson of William McTaggart), and Anne Redpath, whose work perhaps shows the closest affinity with that of Cadell of this group.

Cadell's individual achievements lie in the work he made immediately before the war and that of the 1920s. From when he set himself up in his first studio in the heart of Edinburgh, Cadell's art celebrated the elegance and sophistication of the architecture, interior decoration, society and lifestyle of the Scottish capital, captured in a bravura technique based on a palette held together with black and notes of high colour that remains dazzling today.

[63] Cadell with Ronald, Iain, Marie-Louise and Ion Harrison at Tantallon Castle, near North Berwick, 1936
Private Collection

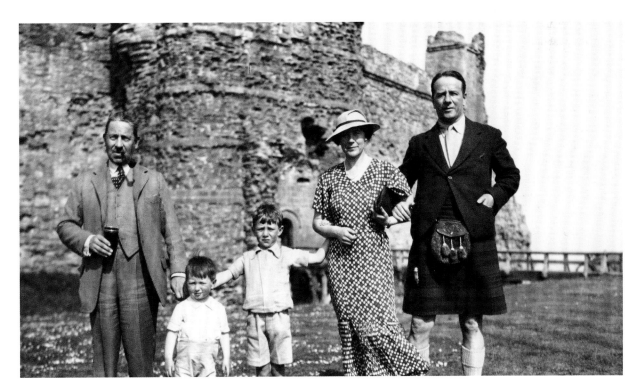

[64]

Inside Iona Croft, early 1930s

Oil on panel, 43 × 35.5
Private Collection

[65]

The Hall, Strachur, 1931

Oil on canvas, 50.8 × 61
Private Collection

[66]
Interior, Croft House, 1932

Oil on canvas, 60.9 × 50.8
Private Collection

[67]
Mrs Ion R. Harrison, 1932

Oil on canvas, 76.2 × 63.5
Private Collection

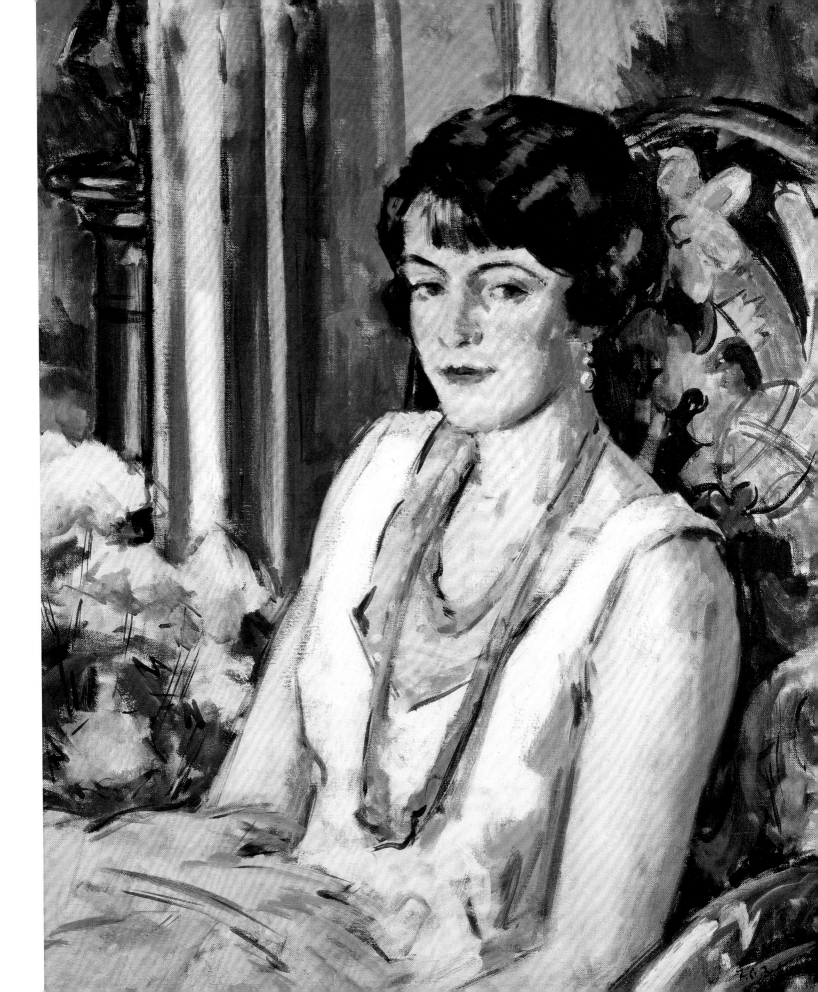

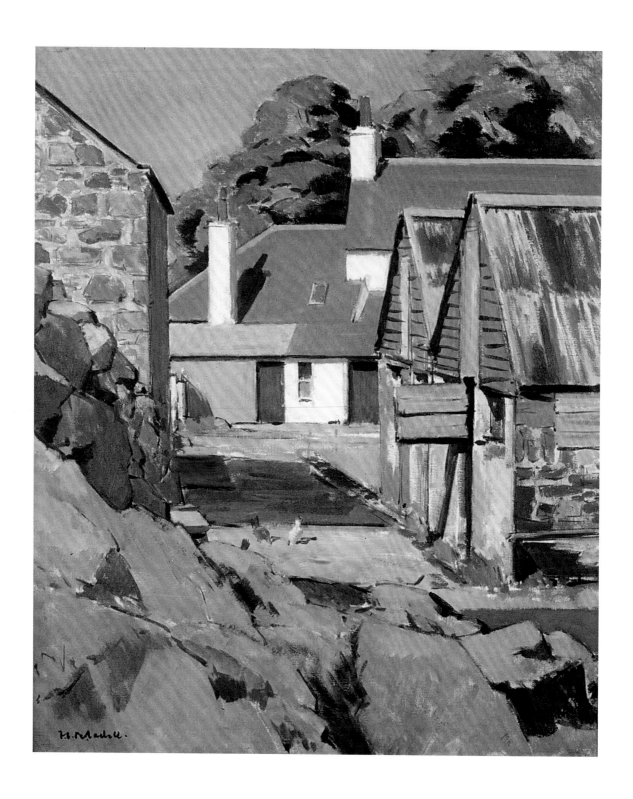

[68]

The Farm, Isle of Mull, c.1930

Oil on canvas, 76.2 × 63.5 · Dundee City Council
(Dundee's Art Galleries and Museums)

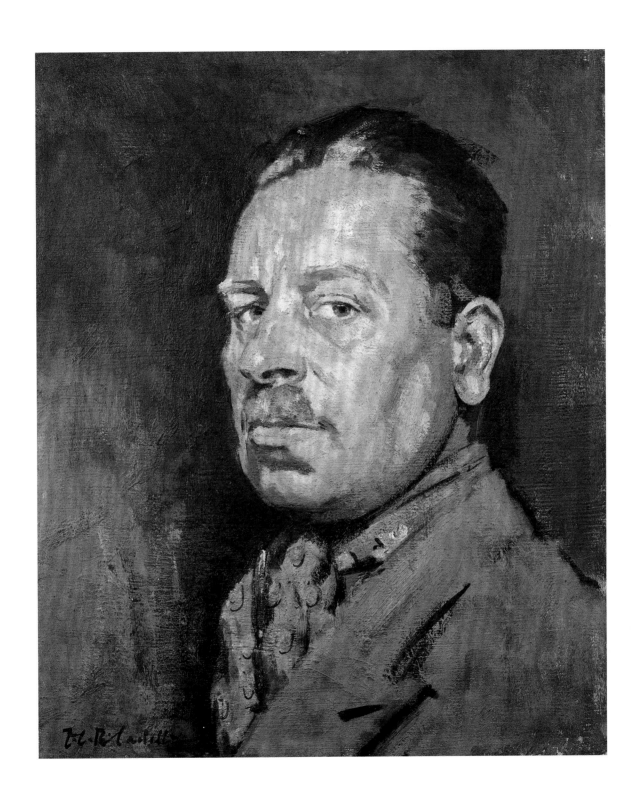

[69]

Myself – Iona, 1932

Oil on panel, 43 × 35.5
Private Collection

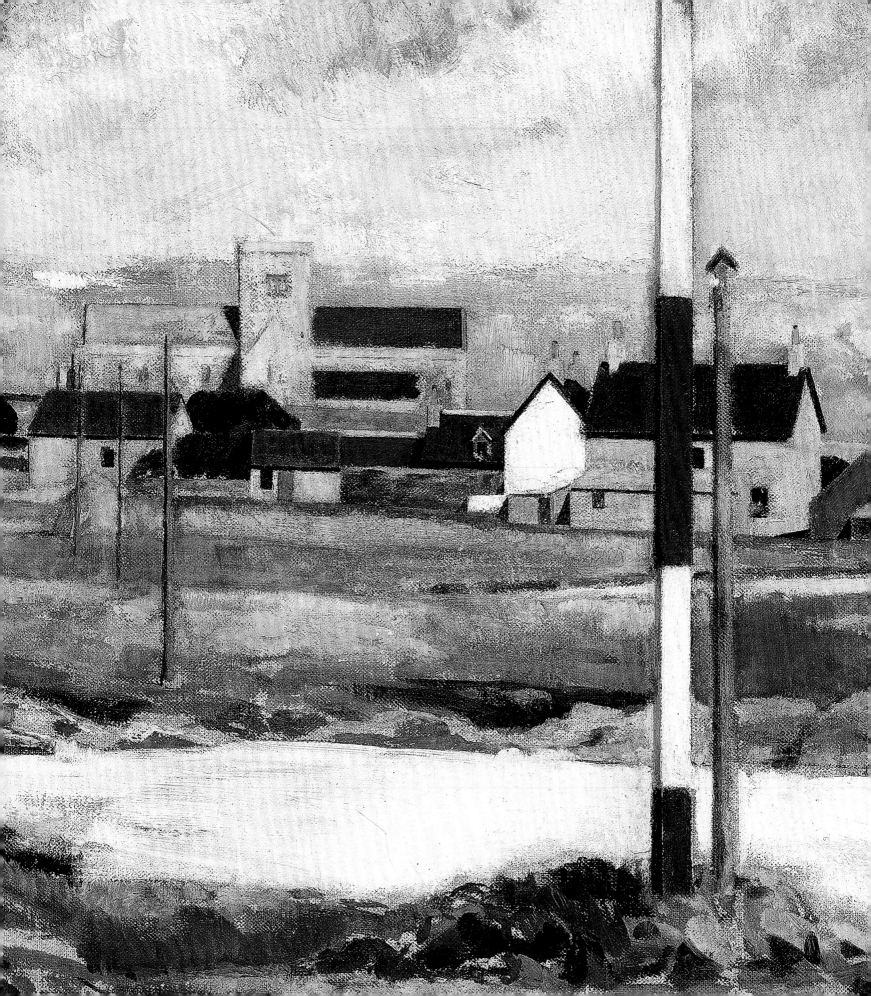

6 · 'Warmed by the sun, blown by the wind'
Cadell and Iona

An unfinished poem which Cadell composed on Iona in 1913 begins 'Warmed by the sun, blown by the wind I sat'.[76] It was written during the second of what were to be virtually annual summer visits to the tiny island until at least 1933. In 563 St Columba had founded his monastery on the site where the Abbey now stands and since the mid-nineteenth century Iona's popularity with artists had been growing. Cadell may have been prompted to visit through personal connections, not least as Ivar Campbell's uncle, the 9th Duke of Argyll, owned the island.[77] Moreover, some of Cadell's artist friends were linked to Iona. Cadell's co-founders of the Society of Eight in 1912, the Celtic Revivalist artist John Duncan and James Paterson began painting there in 1903 and 1909 respectively, whilst William Caldwell Crawford, who knew the island originally through sailing, painted there with Robert Burns in the summer of 1912.[78]

Iona has many attractions for the artist. It measures just over three miles long and one mile wide and is situated off the west coast of the larger island of Mull. It is low-lying, so the light reflected from the surrounding sea intensifies the colours of the white sand beaches and the green of its pastures. The light shining through the shallow waters at the edge of the shore creates brilliant colours of emerald green, blue and violet. In addition, the light and weather change frequently, as the prevailing winds cause a quick succession of cloudy then clear intervals. Iona is known for its geological diversity and there is a wide variation of colours in its rock formations; the red granite of the Ross of Mull is easily visible across the Sound on the east coast, as is the mountain of Ben More. There are also numerous views beyond Iona, particularly from the north end towards Staffa and

the Treshnish Islands. On the island itself, the main architectural features are the Abbey, the Nunnery and related buildings, the village and scattered crofts.

In 1909 *The Studio* journal declared: 'The islanders have become so accustomed to the camp-stool and white umbrella that they pay no more attention to the artist than to peregrine or other birds of passage that in season visit the island.'[79] However, Iona's heyday as an artists' colony was between the wars. The islander and weaver Willie Macdonald described Iona as 'a paradise for painters. You couldn't go up to the north end without passing so many easels.'[80] Soon after being demobilised in 1919, Cadell returned to Iona for the first time since 1914. Whilst on service, Peploe had written to him 'When the war is over I shall go to the Hebrides, recover some virtues I have lost. There is something marvellous about those western seas. Oh, Iona. We must all go together next summer.'[81] Thus in 1920, Peploe (by then nearly fifty years old) accompanied Cadell to the island for the first time and found a new direction for his painting. He too returned for regular summer visits for the rest of his life. With the silversmiths and jewellery designers Alexander and Euphemia Ritchie, who lived in the village and ran the shop Iona Celtic Art in the grounds of the Nunnery, they formed the heart of the island's artistic community. Other members of their circle were the artists William Caldwell Crawford, William Mervyn Glass and William Stewart Orr.

Cadell became a well-known and well-liked character on Iona. Widely referred to as 'Himself' [71], he was happy for people to watch him at work and kept islanders and visitors amused with his witticisms. When a visitor lamented that, due to the excessive strain on Iona's water supply caused by the summer holidaymakers, he had not been able to take a bath for

[70] Detail from
The Village, Iona [87]

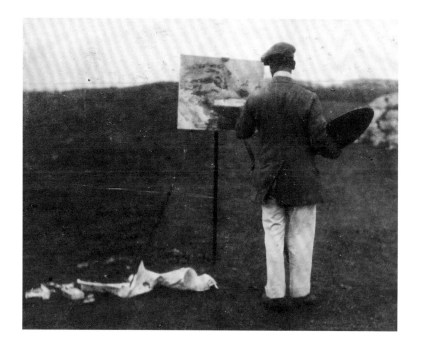

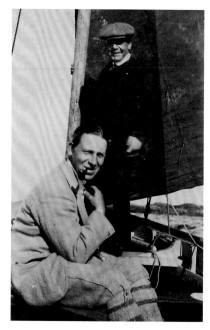

a fortnight, Cadell's response was 'Didn't you know? In Iona you either stink or swim!'[82]

Cadell stayed at the St Columba Hotel during his early visits to the island, using a building across the road as his studio. After the war, accompanied by Charles Oliver, he rented a number of cottages, but the one with which he is most closely associated is Cnoc cùil Phàil [73, 86]. It is half a mile north of the Abbey and overlooks the Sound of Iona towards Mull. Cadell was as concerned with the decoration of his home on Iona as he was in Edinburgh. Ion Harrison, who joined Cadell on the island in 1932, recalled how the first thing the artist would do on arriving at his summer house was to paint the windows and doors green.[83] Meanwhile on the inside, Cadell would pack up his landlady's pictures and ornaments and replace them with his own. As T.J. Honeyman related: 'His sister once remonstrated with him, "You shouldn't do this, you'll hurt Mrs X's feelings." To which Bunty retorted, "What about my feelings. I have to live here."'[84]

The image of Cnoc cùil Phàil that Cadell made in the early 1930s is based on the view looking from one room to another [64], a compositional device that he used to such effect in his interiors of 6 Ainslie Place. This painting of the more humble cottage was given by Cadell's sister Jean to her son, the actors' agent, John Perceval-Clarke. Known as 'Gruff', John changed his surname to Cadell following the death of his father in 1938. As Jean needed to be based between London and

Hollywood for professional reasons, she sent John to Loretto School in Musselburgh, near Edinburgh, to be close to his uncle. For five years from about 1928 until 1933 John spent most Sundays with Cadell and Charles Oliver and accompanied them to Iona in 1932.[85]

As the artist Philip MacLeod Coupe has explained:

Whilst the majority of Cadell's paintings of Iona are of the north end, he painted many other subjects

all over the island, unlike Peploe whose works are almost exclusively of the north beaches. Cadell frequently depicted figures in the foreground, or a yacht sailing by in the middle distance in his paintings. Distant features in views from the north end include the Treshnish Islands such as The Dutchman's Cap and Lunga, and further north, Rhum and the Cuilin of Skye. The small island of Eilean Annraidh, just off shore at the north east corner of Iona, appears in many paintings. To the east, Mull and its highest peak, Ben More, are dominant. Other paintings of Iona include the crofts north of the village such as Clachanach, Auchabhaich, Ardionra and especially Cnoc cuil Phail. Cadell also painted the exterior and interior of the Abbey and other views in the Village, and there are many pictures of the shoreline south of the

In contrast to the urbanity of the work Cadell made in Edinburgh, the over-riding subject matter of his Iona paintings is that of nature. Cadell painted outdoors, frequently on small boards which he usually completed in one session. From about 1920, he and Peploe adopted the technique of using a white gesso ground, probably following the lead of John Duncan, which absorbs paint, allowing the artist to work quickly.[87] The dry, chalky finish that results enhances luminosity and so was particularly suitable for the depiction of Iona's shimmering light. Paintings made in this way should never be varnished, a dictum Cadell meticulously inscribed on the backs of works [74]. During the 1930s Cadell made an increasing number of watercolours on Iona.

Cadell's depictions of Iona sold well on the island and when back in Edinburgh, provided vital income. For example, his Register of Pictures for 1924 records the sale of twenty-two Iona works and over thirty in 1925 and 1926. He rarely submitted them to the Royal Scottish Academy and Royal Glasgow Institute annual exhibitions, but tended to show the results of his most recent stay at the Society of Eight exhibitions. Whilst on the island, Charles would construct simple wooden frames for the works, which he then painted white. The frames help to identify Iona works seen within some of Cadell's other paintings.[88] Legend has it that when potential purchasers arrived at Cnoc cùil Phàil, Charles would show them out of the front door if they bought something, but out of the back door if they did not.[89]

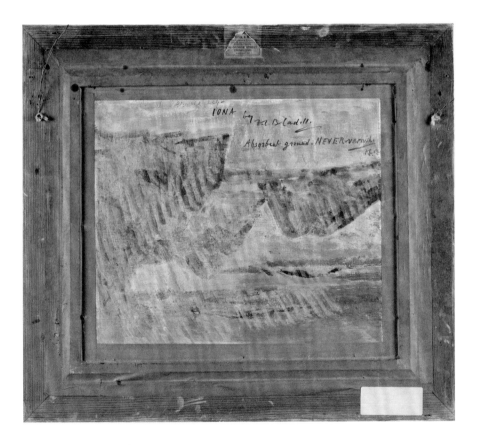

[74] Cadell's instructions on the back of one of his paintings of Iona

Village including the Marble Quarry. The crofts south of the Village featured in his work together with views of the west coast of Iona, including the celebrated sandy cove of Port Bhan. Occasionally he also painted daily life on the island, such as the harvest and boats at the jetty.[86]

Two of Cadell's most important patrons also summered on Iona, namely the shipowner George W. Service and the paper manufacturer David Russell. The widowed Service came each year with his eight children and their nanny [76]. They often rented the farmhouse at Traighmòr, although as it was not large enough to accommodate all of them his sons had to sleep in a tent on the grass at the front of the house.[90] Service would don his tartan dress jacket for the night of his annual purchase of paintings by Cadell and his name appears regularly throughout the 1920s in the Register of Pictures.[91] He often bought several paintings at a time, mainly, but not exclusively of Iona, and amassed a collection of some 150 works, which he hung in his homes in Glasgow and Dunbartonshire.

It was through Service that in 1928 Cadell undertook his only known completed commercial commission, to design three posters for the ferry company

David MacBrayne Ltd [75].[92] Two of the images of Iona featured the paddle steamer the Grenadier, which served the island until its demise by fire in 1927, with the caption 'Scotland's Wonderland by MacBrayne's Steamers'. One of the posters is based on a painting of Cow's Rock in which Service himself is depicted [77].[93] The £350 fee that Cadell received from MacBrayne's constituted almost half of his total income for 1928.

David Russell was a key figure in the plans to renovate Iona Abbey and in the original activities which eventually led to the founding of the Iona Community. He and his family rented various cottages on Iona including Cnoc Mòr, south of the village, which they purchased in 1933. In 1932 he wrote to Cadell: 'We all went down to the pier to see you off, but were just too late. I wonder if you saw us all waving from Cnoc Mòr as you passed down the Sound? We did feel a little anxious about you with such a large company of sheep.'[94]

In 1932 Cadell wrote to Peploe from Iona:

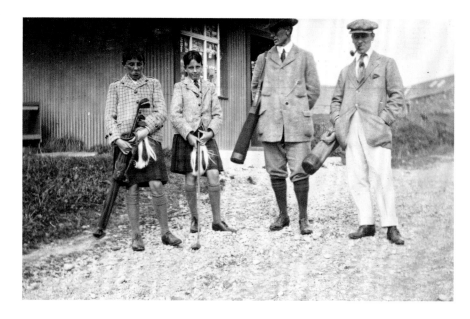

I have painted a few watercolours, 4 or 5 oil panels and a 24 inch square of the Nunnery! This not yet finished as I have only done about ¼ of the stones! The panels consist of 2 of Calbha [sic], one of Clachannach [sic], one of the road running between the hotel and the cabin looking south from opposite the Reilig Odhran [sic] and a portrait of myself done in a diseased mirror and not yet completed. Anything to escape the horrors of Ben More, Loch na Keal and Bourg [sic]![95]

The self-portrait he refers to is *Myself – Iona* [69]. Cadell's last trip to Iona is thought to have been the following year, 1933.[96] The island, which played a vital part in Cadell's career, provided some twenty years of inspiration and subject matter, not to mention critical income from the sale of the resultant paintings. Many of the artists, including Cadell, who had gathered on the island summer after summer during the inter-war period were dead by the end of the Second World War. However, at its peak, Willie Macdonald described Iona as 'a paradise for painters', prominent amongst whom would have been 'Himself'.[97]

[75] Poster designed by Cadell for David MacBrayne Ltd, 1928
Private Collection

[76] Cadell with John, Harvie and George Service, c.1913
Private Collection

SCOTLAND'S
WONDERLAND
BY
MACBRAYNE'S
STEAMERS

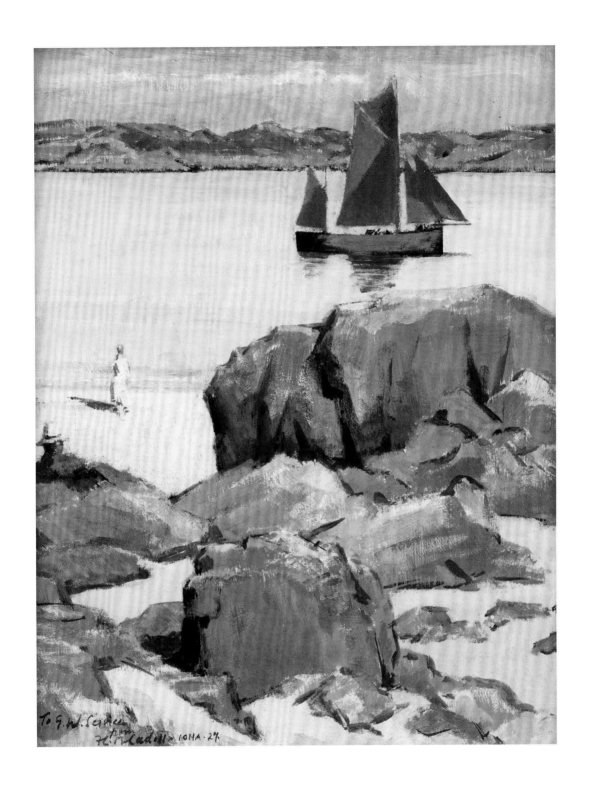

[77]

*Cow's Rock, c.*1927

Oil on panel, 45.5 × 38
Private Collection

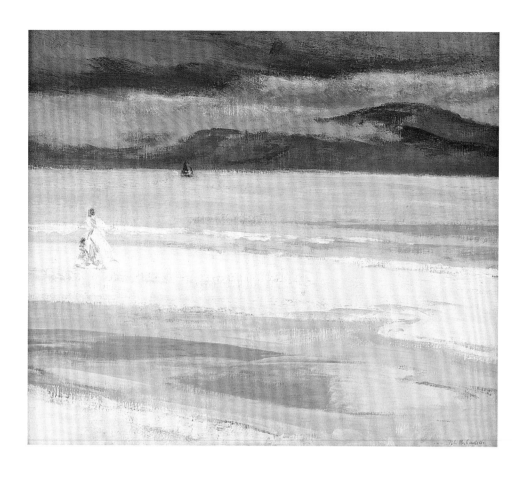

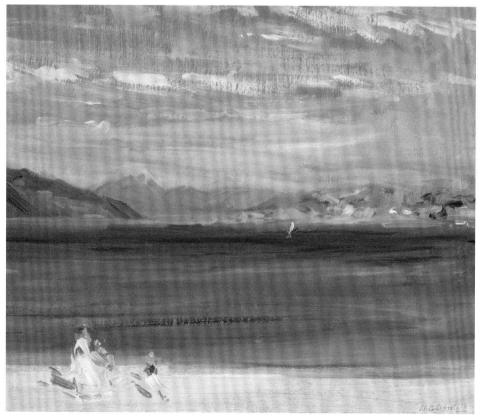

[7 8]
The North End, Iona, c.1914
Oil on panel, 36 × 44
Private Collection

[7 9]
The Tail of Mull from Iona, 1913
Oil on canvas, 37.5 × 46
Private Collection

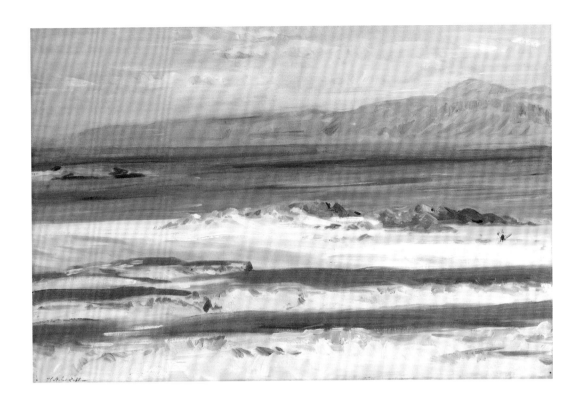

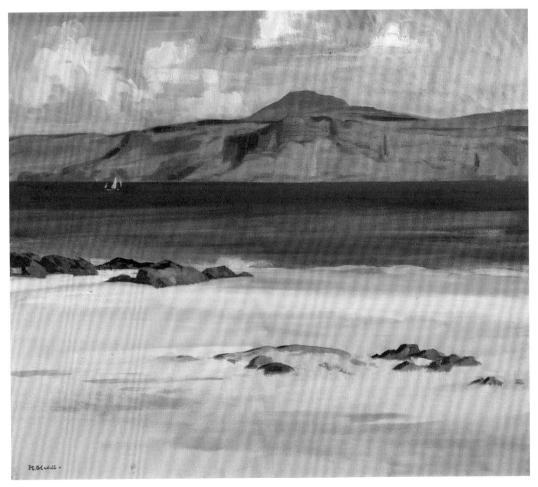

[80]
*Iona Sound and Ben More, c.*1913

Oil on canvas, 50.8 × 76.2
Private Collection

[81]
Burg, late 1920s

Oil on canvas, 63.5 × 76.2
Private Collection

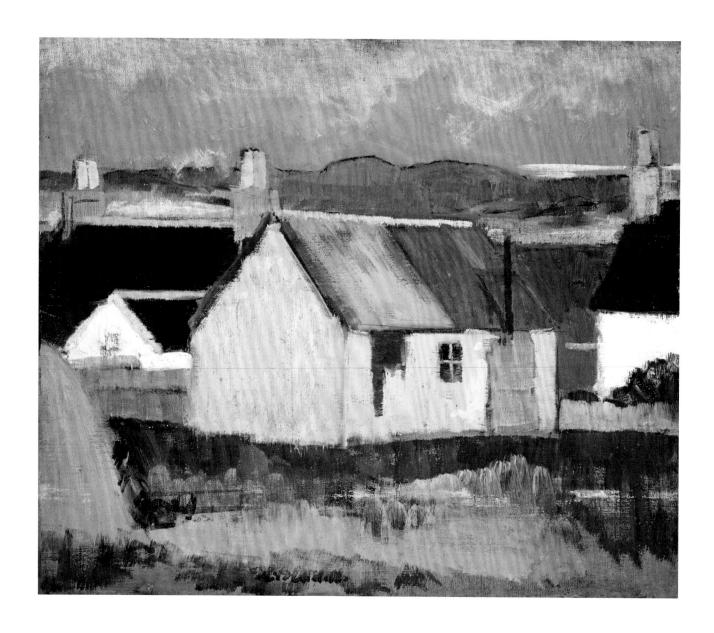

[82]

Iona, mid-1920s

Oil on board, 37.7 × 45
Scottish National Gallery of Modern Art, Edinburgh,
bequeathed by Dr R.A. Lillie 1977

[83]

Interior, Iona Abbey, mid-1920s

Oil on canvas, 70 × 50.8
Private Collection

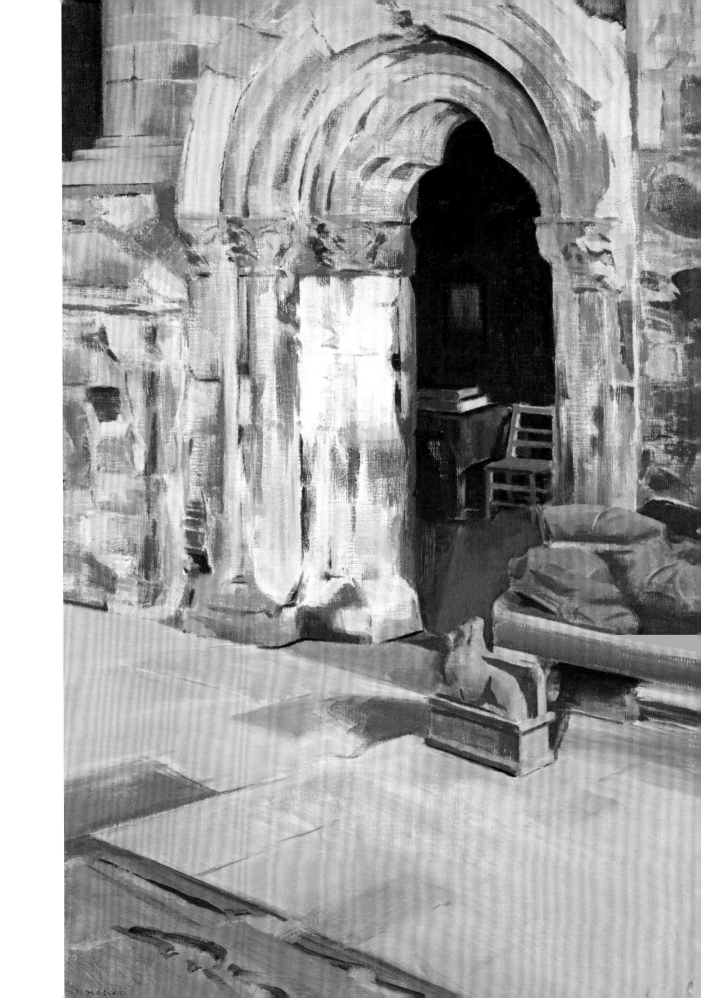

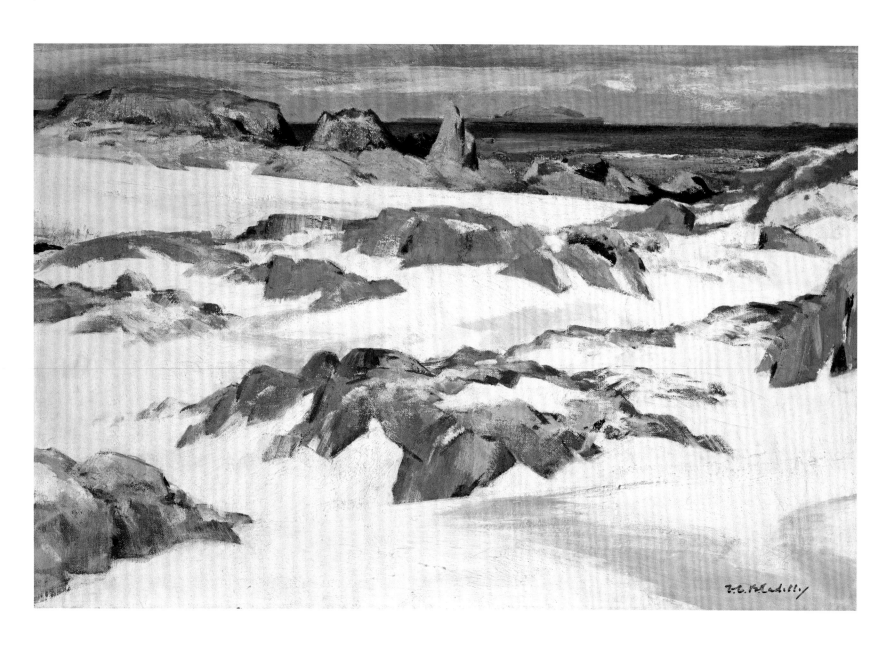

[84]

Lunga from Iona, mid-1920s

Oil on canvas, 51 × 77.2

Private Collection

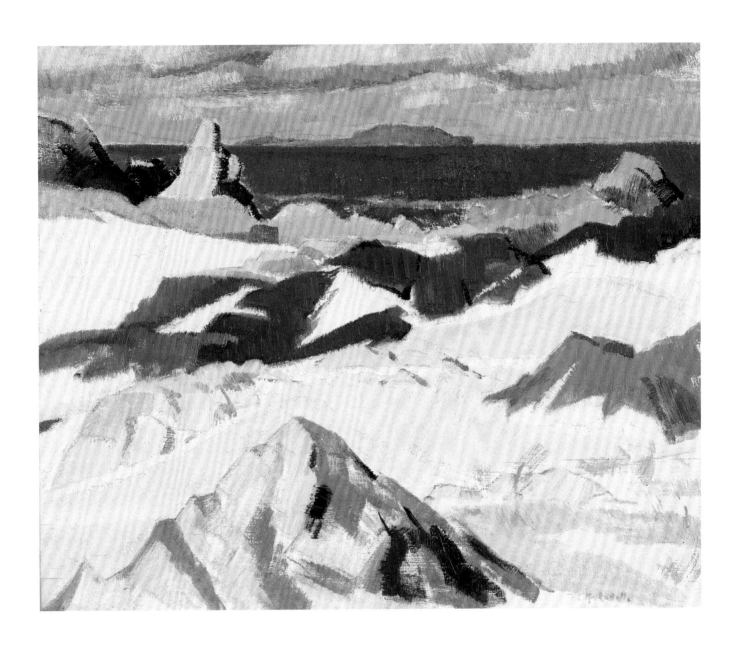

[85]

Pulpit Rock, Iona, early to mid-1920s

Oil on panel, 37.5 × 45.3
Private Collection

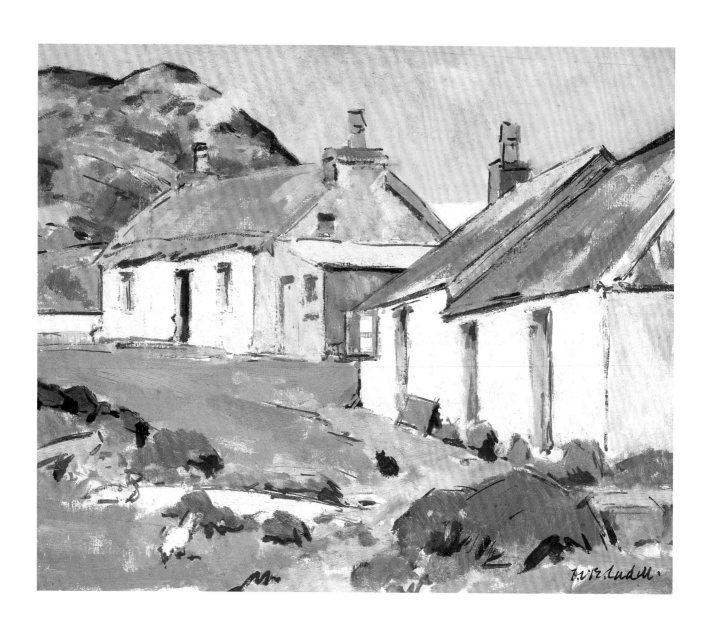

[86]

The Croft, early 1930s

Oil on panel, 40 × 46

Private Collection

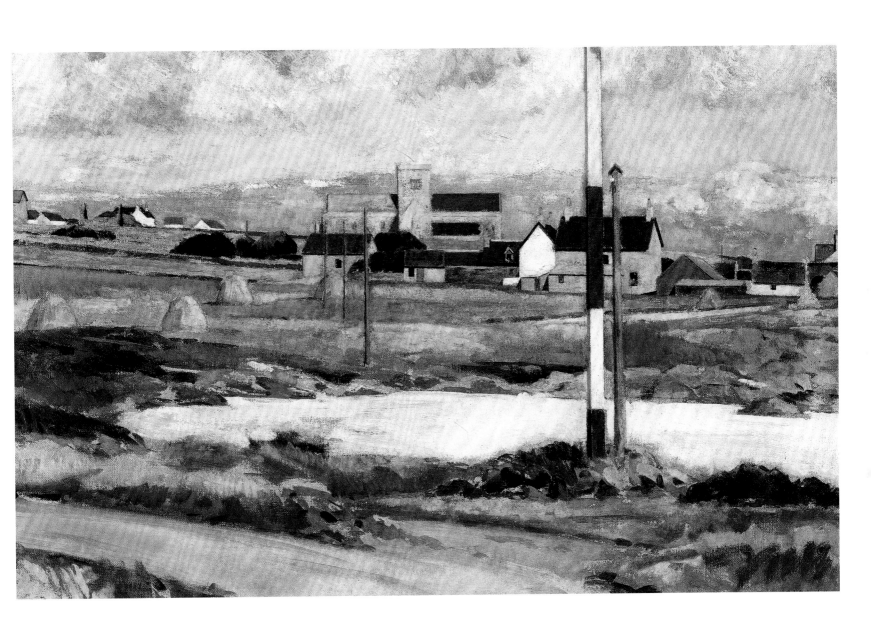

[87]

The Village, Iona, mid-1920s

Oil on canvas, 50.5 × 76
Private Collection

[88] Detail from *Iona* [82]

CHRONOLOGY

1883
Francis Campbell Boileau Cadell born on
12 April at 4 Buckingham Terrace, Edinburgh

1884
Birth of sister Jean Dunlop Cadell

1886
Birth of brother Arthur Patrick Hamilton Cadell

1889
Cadell and his family move to 22 Ainslie Place,
Edinburgh

1898
With his mother and sister, Cadell moves to Paris
and enrolls at the Académie Julian

1902
Family returns to Edinburgh

Exhibits in the Royal Scottish Academy and Society
of Scottish Artists' annual exhibitions for the
first time. From 1902 to 1905 Cadell lives between
Edinburgh and Paris.

1906
Cadell moves with his family to Germany

1907
Cadell enrolls at the Academie der Bildenden
Künste, Munich

Death of mother Mary Boileau Cadell on
16 December in Munich

1908
Cadell and his family return to Edinburgh

First solo exhibition, at Doig, Wilson & Wheatley,
Edinburgh

1909
Death of father Francis Cadell on 12 February

Cadell moves into his first Scottish studio, at
130 George St, Edinburgh

Solo exhibition at The Scottish Gallery, Edinburgh

Exhibits in the Royal Glasgow Institute annual
exhibition for the first time and continues to do so
virtually every year until his death

Exhibits in the Royal Scottish Society of Painters in
Watercolour annual exhibition for the first time, and
again in 1921, 1925, 1935 and 1936.

1910
Painting trip to Venice

Solo exhibition at The Scottish Gallery, Edinburgh

Marriage of sister Jean to Perceval Perceval-Clarke

1912
Co-founder of the Society of Eight exhibiting society

Exhibits in first Society of Eight annual exhibition
and continues to do so until his death

First painting trip to Iona; returns virtually every
summer except during the war and in the very last
years of his life

1914
Two drawings acquired at the Venice International
Exhibition for the city's collection, the first work by
Cadell to enter a public collection

Start of World War One

Marriage of brother Arthur to Beatrice Justice

1915
Joins the 9th Battalion, The Royal Scots as a Private

1916
Publication of Jack and Tommy book of drawings of
army and navy life

Death of Ivar Campbell on 8 January

1917
Solo exhibitions at Doig, Wilson & Wheatley,
Edinburgh and at George Davidson's gallery, Glasgow

1918
Solo exhibition at Alexander Reid's gallery, Glasgow

Commissioned as a 2nd Lieutenant in the 5th
Battalion of the Argyll and Sutherland Highlanders

1919
Demobilised spring 1919

Returns to Iona for first time since 1914

1920
Moves to 6 Ainslie Place, Edinburgh

Travels to Iona with Peploe

1921–2
Solo exhibitions at Warneuke's, Glasgow and The
Scottish Gallery, Edinburgh

1923
Painting trip to Cassis

Exhibition of works by Cadell, Peploe and Hunter at
The Leicester Galleries, London

Solo exhibition at La Sociéte des Beaux-Arts, Glasgow

1924
Painting trip to Cassis with Peploe

Exhibition *Les Peintres de l'Ecosse Moderne* (Cadell,
Fergusson, Hunter and Peploe) held at Galerie
Barbazanges, Paris

Solo exhibition at Alexander Reid's gallery, Glasgow

1925
Exhibition of works by Cadell, Peploe, Fergusson
and Hunter at The Leicester Galleries, London

1926–7
Solo exhibitions at Alexander Reid's gallery, Glasgow

1928
Sells lower four floors of 6 Ainslie Place and moves to
the upper two floors

Poster commission for David MacBrayne Ltd.

Solo exhibition at Reid & Lefèvre's gallery, Glasgow

Death of Alexander Reid

CADELL'S FAMILY AND FRIENDS

1931

Elected an Associate of the Royal Scottish Academy

Les Peintres Ecossais (S.J. Peploe, J.D. Fergusson, G.L. Hunter, F.C.B. Cadell, Telfer Bear, R.O. Dunlop) exhibition held at Galerie Georges Petit, Paris

Solo exhibition at Parsons' Galleries, Edinburgh

Sells upper two floors of 6 Ainslie Place

Death of G.L. Hunter

1932

Moves to 30 Regent Terrace, Edinburgh

Exhibition *Paintings by Six Scottish Artists: Peploe, Fergusson, Hunter, Cadell, Bear, Gillies* held at Barbizon House, London

Solo exhibition at The Scottish Gallery, Edinburgh

Closure of Reid & Lefèvre's gallery, Glasgow

1933–4

Solo exhibitions at Pearson & Westergaard, Glasgow

1935

Elected a member of the Royal Scottish Society of Painters in Watercolour

Moves to a flat at 4 Warriston Crescent, Edinburgh

Death of S.J. Peploe

1936

Elected Academician by the Royal Scottish Academy. Applies to Royal Scottish Academy's Alexander Nasmyth Fund

1937

Death of Cadell on 6 December

1938

Memorial exhibition at the Royal Scottish Academy, Edinburgh

1942

Memorial exhibition at the National Gallery of Scotland, Edinburgh which tours to Glasgow Art Gallery

Patrick William Adam 1854–1929

David Alison 1882–1955

George Telfer Bear 1874–1973

Robert Burns 1869–1941

Francis Cadell 1844–1909
the artist's father

Mary Hamilton Boileau Cadell 1854–1907
the artist's mother

Jean Dunlop Cadell 1884–1967
the artist's sister

Arthur Patrick Hamilton Cadell 1886–1957
the artist's brother

Henry Moubray Cadell 1860–1934

James Cadenhead 1858–1927

Ivar Campbell 1890–1916

George Lyall Chiene 1873–1951

William Caldwell Crawford 1879–1960

Stanley Cursiter 1887–1976

Bethia Hamilton Don Wauchope 1864–1944

John Duncan 1866–1945

Ronald Ossory Dunlop 1894–1973

John Duncan Fergusson 1874–1961

Sir Patrick Ford 1880–1945

William Gillies 1898–1973

William Mervyn Glass 1885–1956

Ion Harrison 1889–1952

Dr T.J. Honeyman 1891–1971

George Leslie Hunter 1877–1931

Beatrice Huntington 1889–1988

Sir John Lavery 1856–1941

William Macdonald 1883–1960

James Pittendrigh Macgillivray 1856–1938

W.Y. MacGregor 1855–1923

Harrington Mann 1864–1937

Arthur Melville 1855–1904

William Stewart Orr 1872–1944

James Paterson 1854–1932

Samuel John Peploe 1871–1935

Alexander Reid 1854–1928

A.J. McNeill Reid 1893–1972

Alexander Ritchie 1856–1941

Euphemia Ritchie 1862–1941

David Russell 1872–1956

John Singer Sargent 1856–1925

George W. Service 1864–1940

Walter Sickert 1860–1942

A.G. Sinclair 1859–1930

Charles Edward Stewart 1885–1967

James McNeill Whistler 1834–1903

NOTES AND REFERENCES

1. Arthur Patrick Hamilton Cadell [1886–1957]. See Billcliffe 1989, p.25.

2. Letter from Cadell to *The Scotsman* of 16 July 1930.

3. Letter from Pittendrigh Macgillivray to Cadell dated 23 February 1915, National Library of Scotland, Cadell papers, Acc.no.11224.

4. The author is indebted to Ian Cadell for his research into the Cadell family tree.

5. 'Obituary: Francis Cadell', *Edinburgh Medical Journal*, vol.2, 1909, pp.270–1.

6. Cadell papers, National Library of Scotland, Acc. no.11224.

7. Cadell left Edinburgh Academy in 1898. Whilst in Paris, Cadell's mother wrote a column for *The Scotsman*, of which the earliest known example was printed on 18 November 1898.

8. Letter from Mary Hamilton Cadell to Francis Cadell of 29 March 1901 in a private collection on loan to the Scottish National Gallery of Modern Art. Cadell appears in the Académie Julian's register of 1898 (as does J.D. Fergusson, although it is not known whether the two Scots met then), listed as aged sixteen and a pupil of J.P. Laurens, see the Archives de L'Académie Julian, Archives Nationales, Paris, 63AS1–9.

9. Undated letter from Cadell to his father, Cadell papers, National Library of Scotland, Acc.no.11224.

10. It has been thought that work by Cadell was included in one of the Paris Salons in 1899, but no records exist to prove this.

11. Cadell was to exhibit with the Royal Scottish Academy regularly, although not annually, throughout his life and with the Society of Scottish Artists at least from 1902 until 1909.

12. The author is indebted to descendants of Ted Stewart for information about his connection to Cadell.

13. For the 1906 Society of Scottish Artists' exhibition Cadell's address is given as the Palais Augustenberg, Gotha, which was a guest house at Lindenauallee 20 run by Miss Marie Seyfarth. The tax list for Francis Cadell held in the Munich City Archives and compiled on 17 February 1908 states that he was a 'Practising Physician', who had been resident at Karlstraße 10, Munich since 29 November 1906. In the academy matriculation book, digitised at http://matrikel.adbk.de, Cadell appears on 4 May 1907 under matriculation number 3328. The author is indebted to Larissa Spicker for her research into Cadell's time in Germany. See tax list for F.C.B. Cadell held in the Munich City Archives and compiled on 28 February 1908, which states that he moved to Nordendstraße 14, 2nd floor on 6 November 1907.

14. In the Post Office Directories of Edinburgh and Leith of 1907 to 1908 the Cadells are still listed at 22 Ainslie Place, but they are not included in those of 1908 to 1909 onwards.

15. No cause of death is given on the death certificate, which is held in the Munich City Archives. The compilation of the tax lists for Cadell and his father in February 1908 were probably undertaken as part of the arrangements to return to Scotland.

16. The Register of Pictures is in a private collection and is the source of much information contained in this book.

17. National Archives of Scotland, SC070/1/490, pp.345–7.

18. Cadell exhibited with the Royal Glasgow Institute virtually every year from 1909 until his death. He is only recorded as having exhibited with the Royal Scottish Society of Painters in Watercolour five times.

19. Peploe's first recorded reference to Cadell is in a letter of 1909 quoted in Peploe 2000, p.33.

20. The author is indebted to the research of Tim Cornwell and the assistance of His Grace the Duke of Argyll and other branches of the Campbell family with regard to the connection between Cadell and Ivar Campbell.

21. See 'Venice (To F.C.B.C.)' in *Poems by Ivar Campbell with Memoir by Guy Ridley*, London 1917, p.41.

22. *Un bar aux Folies-Bergère* was included in the *Exposition Universelle* in Paris in 1900 (no.448), while Cadell was living in the city though it cannot be known if he saw the painting there.

23. The first known reference to Miss Don Wauchope in Cadell's work is a portrait of her shown in the Society of Scottish Artists' exhibition in 1909.

24. Hewlett 1988, p.32. It is not clear which of the Dukes of Argyll (8th, 9th or 10th) gave the kilt to Cadell.

25. Billcliffe 1983, unpaginated.

26. Honeyman 1950, p.83.

27. Honeyman 1950, p.66.

28. The last recorded sale from a Society of Eight exhibition was in 1938. The balance of accounts was written- off in 1954. See the Society of Eight archive at the Scottish National Gallery of Modern Art, Edinburgh, GMA A58.

29. The author is indebted to Major David Meehan for his assistance.

30. The tartan was the Hunting Stewart.

31. The dossier is in a private collection on loan to the Scottish National Gallery of Modern Art, Edinburgh.

32. Peploe 2000, pp.55–6.

33. Peploe 2000, p.56.

34. Peploe 2000, p.57.

35. Letter from Cadell to Mrs Jean Perceval-Clarke dated 9 January 1917, Cadell papers, National Library of Scotland, Acc.no.11224.

36. Ivar's father Lord George Campbell died in 1915.

37. The letter is in a private collection on loan to the Scottish National Gallery of Modern Art, Edinburgh.

38. Letter from Alexander Reid to Charles Stewart dated 12 November 1917, quoted in Fowle 2010, p.121.

39. Peploe 2000, p.56.

40. The author is indebted to the current owners of 6 Ainslie Place for their help in her research and to James Simpson for an explanation of Georgian architecture and architectural terms.

41. As related to the author by a descendant of George Chiene on 18 May 2011.

42. Cursiter 1942, unpaginated.

43. Honeyman 1950, pp.83–4. It has not been possible to find out anything further about Charles Oliver, although there are records detailing his salary from Cadell and other financial matters.

44. Ion Harrison, 'As I Remember Them' in Honeyman 1950, p.124.

45. The author is indebted to Gavin Strang of Lyon & Turnbull for the identification of furnishings.

46. The scrapbook is in the archive of the Scottish National Gallery of Modern Art, Edinburgh GMA A71.

47. It has been thought that the black sitter was the boxer Mannie Abrew of Leith, but as he was born in 1913 this is not possible. The author is indebted to Brian Donald of Leith Victoria AAC for clarifying this point.

48. See J.G.P. Delaney, *Glyn Philpot: His Life and Art*, Aldershot 1999, pl. C4. Cadell's address book, which he began in 1929, is in a private collection.

49. See letter from Cadell to George Chiene of 19 March 1923 in a private collection, on loan to the Scottish National Gallery of Modern Art, Edinburgh GMA AL / 16.

50. Letter from Cadell to George Chiene, see footnote 49.

51. Peploe 2000, pp.68–9.

52. *The Scotsman*, 24 January 1920.

53. *Daily Mail*, 9 January 1923.

54. An Iona landscape by Peploe was acquired by the French nation. See Fowle 2010 p.124 and p.174 footnote no.110.

55. Letter from Cadell to David Russell dated 6 December 1925 in the papers of Sir David Russell, University of St Andrews, MS38515/5/33/1. The author

is indebted to Dr Lorn Macintyre for his help in researching the relationship between Cadell and David Russell.

56. Letter from Cadell to David Russell dated 26 February 1926 in the papers of Sir David Russell, University of St Andrews, MS38515/5/33/1.

57. Letter from A.J. McNeill Reid to Cadell dated 16 November 1928 in a private collection, reproduced in Hewlett 1988, p.70.

58. Honeyman 1950, p.82.

59. Letter from Cadell to David Russell dated [...] 24, 1932, in the papers of Sir David Russell, University of St Andrews, MS38515/5/33/1.

60. Ion Harrison in Honeyman 1950, p.120.

61. Ion Harrison in Honeyman 1950, p.84.

62. The notes are in a private collection on loan to the Scottish National Gallery of Modern Art, Edinburgh.

63. Letter from Cadell to David Russell dated 23 December 1932, in the papers of Sir David Russell, University of St Andrews, MS38515/5/33/1.

64. See various letters between Cadell and Russell from 1933 and 1934 in the papers of Sir David Russell, University of St Andrews, MS38515/5/33/1.

65. See Who's Who online edition, Oxford University Press 2007, http://www.ukwhoswho.com/view/article/oupww/whowaswho/U207044.

66. Ion Harrison in Honeyman 1950, p.124.

67. Application dated 26 August 1936, Cadell papers, National Library of Scotland Acc.no.11224.

68. Stated in a letter from Murray Beith & Murray to Cadell of 11 February 1936, in a private collection on loan to the Scottish National Gallery of Modern Art, Edinburgh.

69. See Hewlett 1988, p.81 and p.88.

70. As related to the author by William Caldwell Crawford's daughter, Joan Faithfull, on 4 July 2011.

71. As told to the author by a descendant of Cadell on 23 May 2011.

72. Cadell's will, National Archives of Scotland, ref. SC70/4/740 p.49–50.

73. As related to the author by a descendant of Cadell on 23 May 2011.

74. Letter from Murray Beith & Murray to the Treasurer, Royal Scottish Academy dated 10 February 1938, Cadell papers, Royal Scottish Academy Archive.

75. The work referred to is *Portrait of Lady Lavery*, now in the collection of the City Art Centre, Edinburgh. The author is indebted to Ian O'Riordan

for information about The Scottish Modern Arts Association.

76. Cadell papers, National Library of Scotland, Acc. no.11224.

77. It is known that Ivar Campbell had been to Iona before 1915, as a letter he wrote to 'Aunt Far' of 11 June 1915 reads 'Go to Iona ... and remember me to [Alex] Ritchie and the others.' Letter printed in *Letters of Ivar Campbell, written between May 1915 and January 1916*, privately published in Edinburgh in 1917.

78. This chapter is indebted to the research of Jessica Christian and Charles Stiller, whose book *Iona Portrayed: The Island through Artists' Eyes, 1760–1960* was published in Inverness in 2000. The information about William Caldwell Crawford was explained to the author by his daughter Joan Faithfull.

79. Christian and Stiller 2000, p.51.

80. Christian and Stiller 2000, p.64.

81. Letter from S.J. Peploe to Cadell dated 2 August 1918, see Peploe 2000, pp.56–7.

82. Honeyman 1950, p.78.

83. See Ion Harrison in Honeyman 1950, p.121.

84. Honeyman 1950, p.90.

85. As related to the author by a descendant of Cadell on 23 May 2011.

86. Letter from Philip MacLeod Coupe to the author 18 July 2011. The author is greatly indebted to Mr MacLeod Coupe's unpublished research into the work that Cadell and Peploe made on Iona.

87. See Christian and Stiller 2000, p.56 and p.59.

88. As explained to the author by Anne Dulau of the Hunterian Art Gallery, Glasgow on 13 October 2010.

89. Hewlett 1988, pp.65–6.

90. As related to the author by a descendant of George Service on 7 February 2011.

91. Christian and Stiller 2000, p.62.

92. See Hewlett 1988, p.69 and Christian and Stiller 2000, p.79 and p.81.

93. As explained to the author by a descendant of George Service on 10 November 2010.

94. Letter from David Russell to Cadell dated 21 September 1932, papers of Sir David Russell, University of St Andrews, MS38515/5/33/1.

95. Letter from Cadell to S.J. Peploe dated 7 July 1932 in a private collection.

96. Cadell did not visit Iona in 1934 and it is thought that from 1935 he was too ill to undertake the trip.

97. See Christian and Stiller 2000, p.64.

SELECT BIBLIOGRAPHY

BOOKS

BILLCLIFFE 1983
Roger Billcliffe, 'Introduction' in *F.C.B. Cadell 1883–1937: A Centenary Exhibition*, Fine Art Society, exh. cat., London 1983

BILLCLIFFE 1989
Roger Billcliffe, *The Scottish Colourists*, London 1989

BILLCLIFFE 2010
Roger Billcliffe et al., *Pioneering Painters: The Glasgow Boys*, Glasgow 2010

CADELL 1916
F.C.B. Cadell, *Jack and Tommy*, London 1916

CHRISTIAN AND STILLER 2000
Jessica Christian and Charles Stiller, *Iona Portrayed: The Island through Artists' Eyes 1760–1960*, Inverness 2000

CURSITER 1942
Stanley Cursiter, 'Introduction' in *F.C.B. Cadell 1883–1937*, exh. cat., National Gallery of Scotland, Edinburgh and Glasgow Art Gallery 1942

CURSITER 1947
Stanley Cursiter, *Peploe: An Intimate Memoir of an Artist and of his Work*, Edinburgh 1947

DULAU AND SKIPWITH 2003
Anne Dulau and Selina Skipwith, *Intimate Friends: Scottish Colourists from the Hunterian Art Gallery and The Fleming Collection*, exh. cat., London 2003

FOWLE 2010
Frances Fowle, *Van Gogh's Twin: The Scottish Art Dealer Alexander Reid 1854–1928*, Edinburgh 2010

HARDIE 1980
William Hardie, *Scottish Painting 1837–1939*, London 1980

HEWLETT 1988
Tom Hewlett, *Cadell: The Life and Works of a Scottish Colourist 1883–1937*, London 1988

HONEYMAN 1950
T.J. Honeyman, *Three Scottish Colourists*, Edinburgh 1950

HONEYMAN AND HARDIE 1970
T.J. Honeyman and William Hardie, *Three Scottish Colourists*, Edinburgh 1970

LONG AND CUMMING 2000
Philip Long and Elizabeth Cumming, *The Scottish Colourists 1900–1930*, exh. cat., Edinburgh 2000

MACMILLAN 1990
Duncan MacMillan, *Scottish Art 1460–2000*, Edinburgh 1990

PEPLOE 2000
Guy Peploe, *S.J. Peploe 1871–1935*, Edinburgh 2000

JOURNALS

Connoisseur, vol.XXXVI, May-August 1913, pp.271–2

The Scots Magazine, vol.120, no.6, March 1984, pp.639–46

Studio, vol.LVII, 1913, pp.323–7

Studio, vol.LXI, 1914, pp.64–6

Studio, vol.LXVII, 1916, pp.56–9

Studio, vol.LXVIII, 1917, pp.95–8

Studio, vol. LXXII, 1917, pp. 114–119

Studio, vol.LXXXVI, 1923, pp.286–7

Studio, vol.CI, 1931, p.375

ARCHIVES

National Archives of Scotland, Edinburgh, will of F.C.B. Cadell, ref. SC70/4/740

National Library of Scotland, Edinburgh, F.C.B. Cadell papers, Acc.no.11224

Royal Scottish Academy Archive, Edinburgh, F.C.B. Cadell papers

Scottish National Gallery of Modern Art Archive, Edinburgh: the Society of Eight Archive (GMA A58); F.C.B. Cadell papers (GMA A33 and GMA A71); and archival material on loan from three private collections (GMA AL/15, GMA AL/16 and GMA AL/21)

The University of St Andrews, papers of Sir David Russell, MS38515/5/33/1

ACKNOWLEDGEMENTS

In addition to those thanked in the Directors' Foreword, the author is grateful to the following people for the sharing of their expertise and provision of information. Our thanks are also due to all those who have contributed and wish to remain anonymous. Nick Adair, George Watson's College, Edinburgh; Marzena Apanasiewicz; Faith and Josh Archer; His Grace the Duke of Argyll; Campbell Armour, Nick Curnow, Douglas Girton, Linda Robinson, John Mackie and Gavin Strang, Lyon & Turnbull; Athina Athanasiadou and Emily Walsh, Bourne Fine Art, Edinburgh; John Bellany; Hildegarde Berwick, East Dunbartonshire Council; Roger Billcliffe, The Roger Billcliffe Gallery, Glasgow; Douglas Breingan and Andrea Kusel, Paisley Museum and Art Gallery; Chris Brickley, Jonathan Horwich and Grant MacDougall, Bonhams; Sharon and Simon Bromberger; Ann Bukantas, Walker Art Gallery, National Museums Liverpool; Ian Cadell; Jennifer Cooper; Alexander Corcoran, Lefevre Fine Art Ltd, London; Jessica Christian and Charles Stiller; Tim Cornwell; Elizabeth Cumming; Brian Donald, Leith Victoria AAC; Anne Dulau, The Hunterian Art Gallery, Glasgow; Simon Edsor, The Fine Art Society, London; Joan, Monty and David Faithfull; Grant Ford, Michael Grist and Anthony Weld-Forester, Sotheby's; Frances Fowle, National Gallery of Scotland, Edinburgh and University of Edinburgh; Jane Freel, Kirkcaldy Museum and Art Gallery; Dr Catherine Gates; Jill Gerber, Cyril Gerber Fine Art, Glasgow; Meredith Gobbi, University of Edinburgh; Ian Gow, The National Trust for Scotland; Andrew Graham, West Dunbartonshire Council; Yvonne Hardman, Touchstones Rochdale; Philip Harley, Nicholas Orchard, Bernard Williams and André Zlattinger, Christie's; Dawn Henderby, Nithsdale, Dumfries and Galloway Council; Daniel Herrmann, Whitechapel Gallery, London; Tom Hewlett, Emily Johnston and Benjamin Walton, The Portland Gallery, London; Nick Holmes, Seymours Art Advisers, London; Matthew Jarron, University of Dundee; Neil Jennings, Jennings Fine Art; Steven Kerr, The Royal College of Surgeons of Edinburgh; Jenny Kinnear, The Fergusson Gallery, Perth; Philip Long, V&A at Dundee; E. Mairi MacArthur; Doug MacBeath, Lloyds Banking Group Archives and Museums; Dr Lorn Macintyre; Philip MacLeod Coupe; Frank McGarry, Royal Bank of Scotland; Neil McGregor, Doncaster Museum and Art Gallery; John McKenzie, John McKenzie Photography; Susan McKeracher and Anna Robertson, Dundee Art Galleries and Museums; Jessica Mander, Edinburgh College of Art; Anita Manning, Great Western Auctions, Glasgow; Alexander Meddowes, Fine Art Broker, Edinburgh; Major David Meehan; Gordon and Fiona Menzies, Iona Gallery and Pottery, Isle of Iona; David Michie; Duncan Miller, Duncan R. Miller Fine Arts, London; Jean Milton, The Potteries Museum & Art Gallery, Stoke-on-Trent; Sandy Moffat; Susan Morris, Richard Green Gallery, London; Ewan and Carol Mundy, Ewan Mundy Fine Art, Glasgow; Ian O'Riordan and David Patterson, City Art Centre, Edinburgh; Guy Peploe, The Scottish Gallery, Edinburgh; Judy and Robbie Reid; Dr Norman Reid, Special Collections, University of St Andrews; Merlin Seller, University of St Andrews; John Scott Moncrieff, Murray Beith Murray; Kirsten Simister, Ferens Art Gallery, Hull; James Simpson; Selina Skipwith, The Fleming Collection, London; Inge and Peter Sloan; Bill Smith; Dr Ian Smith, Edinburgh Napier University; Dr Joanna Soden, Royal Scottish Academy; Larissa Spicker, University of Munich; Hugh Stevenson, Kelvingrove Art Gallery and Museum, Glasgow; and Gavin, Patsy, Robert and Thomas Strang. Professor Henry Walton; David Webb, Webb Valuations; Adrian Wiszniewski; George Woods, McLean Museum & Art Gallery, Greenock